LAKE GEORGE
SHIPWRECKS
AND
SUNKEN HISTORY

LAKE GEORGE
SHIPWRECKS
AND
SUNKEN HISTORY

JOSEPH W. ZARZYNSKI
& BOB BENWAY

Published by The History Press
Charleston, SC 29403
www.historypress.net

Copyright © 2011 by Joseph W. Zarzynski and Bob Benway
All rights reserved

Cover images courtesy of Tim Cordell and Dick Dean, both images from the Lake George Historical Association Collection, and Kelly Flatebo and Bob Benway.

First published 2011
Second printing 2012

Manufactured in the United States
ISBN 978.1.60949.220.5

Library of Congress Cataloging-in-Publication Data

Zarzynski, Joseph W.
Lake George shipwrecks and sunken history / Joseph W. Zarzynski and Bob Benway.
p. cm.
Includes index.
ISBN 978-1-60949-220-5
1. Shipwrecks--New York (State)--George, Lake (Lake)--History. 2. Underwater archaeology--New York (State)--George, Lake (Lake) 3. Underwater exploration--New York (State)--George, Lake (Lake) 4. Material culture--New York (State)--George, Lake (Lake)--History. 5. George, Lake (N.Y. : Lake)--History. 6. George, Lake (N.Y. : Lake)--Description and travel. 7. George, Lake (N.Y. : Lake)--Antiquities. 8. George, Lake (N.Y. : Lake)--Discovery and exploration. I. Benway, Bob. II. Title.
F127.G3Z37 2011
974.7'51--dc22
2011001419

Notice: The information in this book is true and complete to the best of our knowledge. It is offered without guarantee on the part of the authors or The History Press. The authors and The History Press disclaim all liability in connection with the use of this book.

All rights reserved. No part of this book may be reproduced or transmitted in any form whatsoever without prior written permission from the publisher except in the case of brief quotations embodied in critical articles and reviews.

To the two most important people in my life: my devoted and hardworking wife, Pat Meaney, and my lovely and talented goddaughter, Lisa Randesi.
—*Joseph W. Zarzynski*

To Deb, for patiently listening to all my stories.
—*Bob Benway*

CONTENTS

Preface 11
Acknowledgements 13

1. Native American Watercraft
Native American Canoes from Lake George 15

2. French and Indian War Shipwrecks
Operation Bateaux: 1963–1964 19
Missing, Four Shipwrecks of the Sunken Fleet of 1758 22
Lake George: Birthplace of the "Modern" American Navy 25
Reputed 1758 Radeau Shipwreck Artifact Sent to Lake George 27
Is Scour an Emerging Scourge at Radeau Shipwreck? 30
No State Destination Sign for the *Land Tortoise* Shipwreck 32
Class Explores Schenectady, New York Connection to
 Lake George Bateaux 34
Raising the Sunken Fleet, the 250th Anniversary 36
Twentieth Anniversary: Discovery of 1758 *Land Tortoise*
 Radeau Shipwreck 39

Contents

3. Nineteenth-Century Shipwrecks

Saluting Bolton's *Cadet* Steam Launch Shipwreck	43
"Old Time Barge" Relocated by Underwater Archaeological Team	46
Has the Steam Yacht *Ellide* Been Found?	48
The *Minne-Ha-Ha* Steamboat Wreck: A Mystery Recently Uncovered	51

4. Twentieth-Century Shipwrecks

Seventy-Five-Year-Old Shipwreck Found and Identified	55
The *Scioto* Shipwreck: Investigating the Stabilization Option	58
Outboard Racing Boat Discovered During Sonar Survey	60
Steamboat *Pamelaine I* Wreck Parts Found	63
Divers Present Saunders with Steamboat Relics	64
Steamboat Whistle Recovered from *Pamelaine* Canopy Wreck	67
Cold Case: 1926 Mystery of Two Missing Hunters (Part One)	69
Cold Case: 1926 Mystery of Two Missing Hunters (Part Two)	71
Dive Commemorates Forty-Fifth Anniversary of Sinking of Lake George's Mystery Sub	74
Hague Mystery Wreck	76
Has Racing Royalty's Boat Been Found in the Lake?	78
Studying the "Wreck" in a Lake George Shipwreck	80
Bateaux Below Proposes *Forward* Shipwreck for National Register	82
Forward Shipwreck Passes State Register of Historic Places	83
Lake George's Sunken Vessel *Onaway II* Located	85
Recent Shipwreck Find a Reminder of a "Lucky Fisherman"	87

5. Historic Preservation & Threats to Shipwrecks

Historic Preservation Legislation Remembered	91
Zebra Mussel Monitoring Station Reactivated at Shipwreck Preserve	93
Spread of Zebra Mussels Could Threaten Lake's Shipwrecks	95

6. Other Submerged Cultural Resources

Evidence of Lake George Lumber Industry Found Underwater	97
Unfortunate Milestone Reached: Thirty Thousand Pieces of Litter Removed from Lake	99

Contents

Launching Wooden Runabouts Using Lake George's "Submarine Railway"	101
Submerged D&H Marine Track Damaged	104
Is Lake George Holy Water? Divers Find Hindu Statuettes in the Lake	106
Counting "What Lies Below"	108

7. Replica Archaeology, Art/Science, Divers and an Urban Legend

Replica Archaeology: 1758 Bateau "Wreck" Sunk in Lake George	111
Lake Art to Be Exhibited in Gallery, Internet and Underwater	113
Wrapping Up the Art/Science Exhibit	115
State Scuba Convention in Lake George	117
Lake George Urban Legend Reaches Washington, D.C.	119
What to Do with Replica 1758 Bateau "Wreck" in Lake	121

8. Shipwreck Documentaries, Shipwreck Preserves and Bateaux Below

Documentary about Lake George Being Filmed	123
The Lost Radeau to Appear on PBS Television	124
Lake George Documentary Wins Film Festival Award	126
Maria's Reef: Bateaux Below's New Submerged Geological Preserve?	128
Lake George Shipwreck Preserves to Get Overhaul	131
Remodeling of Lake's Shipwreck Preserves Continues	133
Unseen Battleground: Improving the "Ring-Around-a-Radeau"	135
Damaged Shipwreck Preserve Repaired and Reopened	137
Painting Lake George's History	138
Mystery Bottle with Written Messages Found in Lake	140
Bateaux Below Celebrates Twenty Years of Underwater Archaeology	142
1987 Lake Champlain Shipwreck Find Helped Train Lake George Underwater Archaeology Team	145

Contents

Conclusion
Lake George Has Crucial Role in State's Underwater Blueway Trail 147

Index 151
About the Authors 159

PREFACE

The chapters in this book help interpret Lake George's heritage. It would be hard to imagine such a history without telling the story of the waterway's vessels, embodied in the more than two hundred known shipwrecks found in the lake. The waterway's saga is one of a diverse people who plied the lake in Native American canoes, colonial warships, watercraft that aided the region's settlement and, more recently, vessels of all types that played an integral role in the development of Lake George as a world-class resort. Helping to uncover this hidden history is the science of underwater archaeology, the study of past peoples by an examination of their material culture in a submerged environment. This book combines the archival record with underwater archaeology to get a clearer perspective of Lake George's maritime and military history.

The vast majority of the sections published in this book first appeared as news articles in our column in the *Lake George Mirror*. The popular Lake George, New York newspaper is published weekly during the spring, summer and autumn and then printed monthly over the off-season, the winter. Most of the book's sections were originally published in the *Lake George Mirror* from 2004 to 2010. The genesis for the newspaper column was to inform about the ongoing work of Bateaux Below, Inc., a not-for-profit corporation that, for twenty-three years, has studied Lake George shipwrecks and its other sunken heritage. Those newspaper articles were written in a third-person style to give us greater freedom in reporting Lake

Preface

George's underwater history. Furthermore, for this publication there was editing of the original newspaper columns to better fit the flow of the book. We hope you enjoy the accounts in these pages and hope that they will encourage you to support history and underwater archaeology programs in your area.

ACKNOWLEDGEMENTS

This book would not have become a reality without the support of many individuals and groups. At the top of this long list is Anthony F. Hall, editor and publisher of the *Lake George Mirror*, a newspaper "devoted to the interests of the Queen of American Lakes" that was first published in 1880. Furthermore, special recognition goes to Bateaux Below's trustees and our longtime colleagues: Dr. Russell P. Bellico, Vincent J. Capone, Terry Crandall and John Farrell. Their friendship, support and sweat equity made significant contributions to many of the sections published in this book. Peter and Joe Pepe (Pepe Productions) and John Whitesel assisted with computer support and image contributions. Whitney Tarella, our commissioning editor at The History Press in Charleston, South Carolina, was generous with her time and was always prompt in answering our many questions during the book production process. Pat Meaney, wife of Joseph W. Zarzynski, deserves our gratitude, too, for assisting with the book's index. Village of Lake George Mayor Bob Blais has a long tradition of advocating for historic preservation and heritage tourism projects at Lake George. There are many volunteers who were generous in giving their time and expertise toward Bateaux Below projects. Several, however, deserve special mention: Dr. D.K. Abbass, Bill Appling, Pete Benway, Dr. Sam Bowser, Steve Cernak, Tim Cordell, Paul Cornell, Christine Dixon, Jeremy Farrell, Dr. Alexey Khodjakov, Martin Klein, Dr. Mike Koonce, Garry Kozak, Kendrick McMahan, Maria Macri (deceased), Lisa Miller, Elinor Mossop, Scott

Acknowledgements

Padeni, Steven C. Resler, Wayne Smith, John Strong, Melodie Viele, Laura Von Rosk, Jane Wait, John Wimbush and Joe Wylie. Several State of New York and local officials also played integral roles, supporting Lake George historic preservation programs: Alan Bauder, retired, New York State Office of General Services; John Carstens, New York State Office of General Services; Dave Decker, Lake George Watershed Coalition; Mark Peckham, New York State Office of Parks, Recreation and Historic Preservation; Dr. Christina Rieth, New York State Museum; Curt Truax, New York State Department of Environmental Conservation; Chuck Vandrei, New York State Department of Environmental Conservation; Gary West, New York State Department of Environmental Conservation; and Mike White, Lake George Parks Commission. There are two local not-for-profit groups that have been longtime supporters of Bateaux Below and projects that protect Lake George's submerged cultural resources: the Fund for Lake George, Inc., and the Wiawaka Holiday House. Finally, a special thank-you to our new friends at The History Press, for publishing great history books that inform us about our country's rich heritage.

Chapter 1
NATIVE AMERICAN WATERCRAFT

Native American Canoes from Lake George

For many centuries, long before Lake George became a popular resort destination, the thirty-two-mile-long waterway and the forestland around it were seasonal fishing waters and hunting grounds for Native Americans. The earliest Native American vessels at Lake George were dugout canoes, wooden watercraft fashioned from logs. After removing the log's bark, the timber's interior was hollowed out by a controlled burn, and then it was hand carved, using an adze or other tool. The log's ends were often tapered to give it a more hydrodynamic design. The indigenous peoples at Lake George later used bark canoes that were considerably easier to maneuver in the water and were also lighter to pull up on shore or to portage.

Canoes were powered by one or more Native Americans, each canoeist with a single-bladed paddle. Because the paddlers faced in the direction they were going, unlike traditional European-style rowed watercraft, it gave the occupants an advantage in navigation.

The Lake George Historical Association (LGHA), a museum in the Old Courthouse Building in the town of Lake George, has a Native American dugout canoe on exhibit. The 15.5-foot-long watercraft dates to the fifteenth century. The LGHA's dugout canoe was reportedly discovered in 1915, found by Edward H. Moon and Clayton N. Davis of Fort Edward, New York. The crude vessel was recovered from the mud of Dunham's Bay Creek

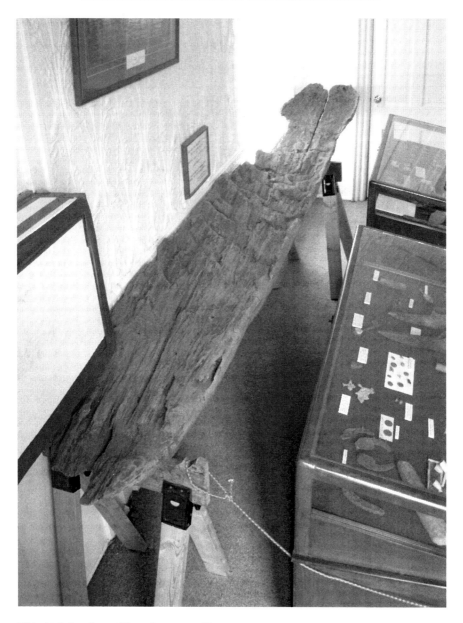

This 15.5-foot-long, fifteenth-century Native American dugout canoe is exhibited at the Lake George Historical Association. It was discovered in 1915, recovered from "the mud of Dunham's Bay Creek on the east side of Lake George." *Courtesy of Bob Benway/Bateaux Below.*

on the east side of Lake George. Several dugout canoes are also in Fort William Henry Museum's collection in Lake George.

In the 1960s, some scuba divers reported seeing Native American bark canoes resting in Basin Bay on the west side of the lake. On September 3, 1983, a partially buried Native American bark canoe was observed in Lake George near Diamond Point by scuba divers Jack Sullivan, his son, John, and Joseph W. Zarzynski.

Bark canoes were built in a variety of sizes, from the one-man hunting and fishing canoe to canoes large enough to transport a war party or a ton of trade goods. Native American bark canoes were generally constructed of birch, elm or hickory bark that was reinforced by a light wooden frame. Its lightweight, relatively fast boat speed and load-carrying capacity impressed the early Europeans. However, bark canoes often required frequent repairs to fix tears and holes.

Finding a centuries-old Native American bark canoe is rather rare since their fragile forms are quite perishable, unlike the durable dugout canoe, whose form is exhibited in many museums around the region. Furthermore, it is difficult to preserve Native American bark canoes for museum exhibition since, as they age, the bark becomes brittle and, therefore, can easily be damaged.

Generally speaking, bark canoes of various sizes, differing materials and methods of construction were found within a single tribal area. Often when Native Americans moved into other areas, they were quick to borrow construction techniques and forms from neighboring tribal groups. Nevertheless, the distinctive feature of an American Indian canoe that generally identifies the tribe is the profile of the ends of the bark canoe.

Ironically, many lake residents and visitors today enjoy canoeing or kayaking on the Queen of American Lakes, using watercraft designs traced back to early Native Americans.

Chapter 2
French and Indian War Shipwrecks

Operation Bateaux: 1963–1964

Published June 4, 2004, Lake George Mirror

Over forty years ago, Terry Crandall, a scuba diver who worked for the Adirondack Museum, conducted two summers of archaeological fieldwork, mapping several dozen sunken bateaux, the twenty-five- to forty-foot-long French and Indian War–era vessels found on the bottomlands of Lake George. Thus, it was not surprising that on June 5, 2004, the New York State Divers Association honored Crandall as its Diver of the Year at the organization's state convention held in Lake George.

Crandall, a former teacher and school administrator, started exploring the deep in the 1950s when he dived Canadarago Lake in Richfield Springs, New York, using Miller Dunn hard hat equipment. In the early 1960s, he taught scuba classes in Johnston, Gloversville, Oneonta, Herkimer and Cooperstown, New York. From 1964 to 1965, Crandall was president of the New York State Divers Association when the group's annual convention those two years was held at Dunham's Bay Lodge at Lake George.

In 1963, Crandall was hired by the Adirondack Museum and was designated as a "diver archaeologist" by the Blue Mountain Lake museum's Dr. Robert Bruce Inverarity. Crandall's task was to explore the depths of Lake George, searching for shipwrecks of the Sunken Fleet of 1758, 260

Terry Crandall was the Adirondack Museum's archaeological diver during Operation Bateaux from 1963 to 1964. *Courtesy of Terry Crandall.*

bateaux and several other classes of warships deliberately sunk by the British to prevent them from falling into the hands of their enemy, the French. The 1963–1964 project was conducted under a permit granted by the New York State Education Department, and the endeavor was appropriately dubbed "Operation Bateaux."

Although Operation Bateaux was primarily a one-person dive operation, Crandall often teamed up with other local divers who volunteered their time and expertise. Most notable of these were Lee Couchman, Charlie Dennis, Gene Parker and Jack Sullivan. According to Crandall, search dives were conducted along "a bottom contour depth of from fifteen- to twenty-five-foot average" following a zigzag pattern "forty-five degrees east and west of [a lubber line]." Warren County sheriff Robert Lilly and the Lake George Park Commission provided boat support to and from the dive sites. After completing these scuba forays, Crandall recorded his search area and finds

on the Lake George Power Squadron charts "using a gridded overlay…[so that] a day's search [zone] could be described with a few six digit codes." Crandall's grid system permitted him to accurately record his shipwreck discovery locations onto lake charts. The two-year effort resulted in a site map of more than thirty colonial bateau wrecks being located and mapped.

When Crandall found a sunken bateau whose structural integrity looked good, he would hand-fan the mud overburden to expose the pine planks and oak frames for photographic purposes. In some cases, artifacts such as "clay pipe fragments, musket and bird shot of all sizes, even…cuff links [that] were found lying on [bateau] floor boards" were removed. Those artifacts and his numerous field reports were then transported back to the Adirondack Museum.

Crandall was innovative, too. He collected measurements of bateaux using "a metal retractable ruler on a piece of clear plexiglass panel." The plexiglass "enabled site drawings to be made looking through the panel to approximate angles as they existed."

Crandall discovered that many sunken bateaux had amazing states of preservation, as some "showed definite signs of caked mud tracking from the shoes of the 'troops,' which could be removed quite intact from the bottom boards themselves."

Unfortunately, bureaucratic problems and the departure of Dr. Inverarity from the Adirondack Museum in the mid-1960s contributed to the cessation of Operation Bateaux after only two years' duration. However, in 1988, Crandall became a member of the archaeological organization Bateaux Below, and he now serves as one of the not-for-profit corporation's trustees.

The legacy of Crandall's 1963–1964 Operation Bateaux is very much evident today. His pioneering archaeological recording conducted over four decades ago established baseline data that is frequently utilized today by Bateaux Below in its study of the lake's Sunken Fleet of 1758.

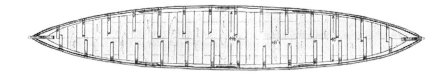

Terry Crandall's drawing of a typical 1758 British bateau, based on the archaeological record from Lake George. *Courtesy of Terry Crandall.*

Missing, Four Shipwrecks of the Sunken Fleet of 1758

Published July 23, 2004, Lake George Mirror

In the autumn of 1758, British forces at Lake George completed a deliberate sinking of its battle craft to prevent them from falling into the hands of the French and their Native American allies. British and provincial soldiers sank 2 floating gun batteries called radeaux, the sloop *Earl of Halifax*, some row galleys and whaleboats and 260 bateaux. This group, known as the Sunken Fleet of 1758, was submerged because Fort William Henry had been destroyed, and, thus, there was no British garrison to protect their flotilla over the winter. The plan was to retrieve these submerged boats the following year, when the British returned to Lake George. Two centuries later, in 1963–1964, many bateaux of the sunken fleet were investigated by the Adirondack Museum. However, more recently underwater archaeologists with Bateaux Below have studied these French and Indian War–era vessels and are perplexed by their findings. Four bateau wrecks noted during the 1960s are missing!

The colonial bateau was the utilitarian vessel of inland waterways during the colonial period. *Courtesy of Mark Peckham.*

French and Indian War Shipwrecks

The bateau (spelled bateaux in the plural) was twenty-five to forty feet long, flat bottomed and pointed at the bow and stern. Fashioned from pine planks and oak frames, a bateau could be rowed, poled in shallow water or rigged with a crude mast and sail. An oar was latched to the stern for steerage.

Throughout the nineteenth and early twentieth centuries, the *Lake George Mirror* newspaper reported that several bateaux were observed in the shallows of the waterway. Decades later, in 1960, two teenage scuba divers "discovered" several submerged bateaux lying near the head of the lake. In September 1960, several of these warships—probably three—were raised by the Adirondack Museum. They were conserved and today are in storage at the New York State Museum.

In 1963–1964, Terry Crandall, a diver hired by the Adirondack Museum, located more than thirty bateau wrecks in the lake's southern basin. His site map, still used today, provides baseline data for underwater archaeologists.

From 1987 to 1991, Bateaux Below surveyed seven vessels known as the Wiawaka Bateaux Cluster. In 1992, these seven shipwrecks were listed on the National Register of Historic Places.

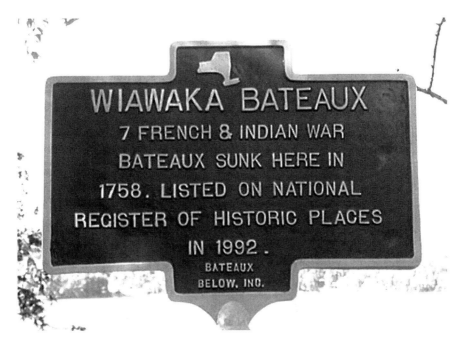

This blue and yellow historical marker was erected on the grounds of the Wiawaka Holiday House. *Courtesy of Joseph W. Zarzynski/Bateaux Below.*

However, one aspect about the remnants of the Sunken Fleet of 1758 is mystifying. Four sunken bateaux located and mapped forty years ago have vanished.

Crandall mapped eight shipwrecks at the Wiawaka Bateaux Cluster rather than the seven there today. Also gone are 1) a bateau that had been embedded into the lake bottom at the mouth of a stream, 2) a bateau that was located off an island and 3) a bateau that was part of a group of five bateau wrecks.

After years of studying these historic vessels, Bateaux Below members think they know what might have happened to these missing warships.

On July 27, 1965, the *New York Times* reported that the New York State Police was conducting a "summer-training program" to recover the 1758 bateaux from the lake's bottomlands. A photograph in that article shows divers handing bateau planks and frames to personnel aboard a state police pontoon boat.

Furthermore, prior to the Wiawaka Bateaux Cluster being opened as a shipwreck preserve for diver recreation in 1993, the site's bateaux were visited by scuba enthusiasts, and unfortunately, some of the colonial craft were obviously disturbed. During a reconnaissance dive to the Wiawaka site by Bob Benway and Joseph W. Zarzynski on June 19, 2004, the pair may have found the location where the missing eighth bateau once rested.

On October 7, 1995, Benway and Zarzynski made a reconnaissance dive, searching for the bateau deposited off one of the streams that empties into the lake. Surprisingly, it was not found. However, after comparing recent aerial photography with 1960s-era maps and consulting with local scientists at the Darrin Fresh Water Institute, it was hypothesized that the AWOL bateau had been covered with sediment from a delta created by sediment runoff over the past four decades.

Another bateau, observed in the 1960s lying off Diamond Island, has disappeared, most likely removed piece by piece due to diver intrusion.

Investigative work determined that the fourth missing bateau, part of a cluster of five shipwrecks, was removed from Lake George during a non-sanctioned salvage in the 1960s or 1970s. Furthermore, another bateau in that group lies on a lifting cradle of cinder blocks and lumber, and it was severely damaged from this removal attempt.

To date, approximately forty bateaux have been recorded on Bateaux Below's submerged cultural resources inventory list. However, the seven Wiawaka bateaux are the only bateau wrecks that are listed on the National

Register of Historic Places. Also, the Wiawaka bateaux are part of a shipwreck park for divers called Submerged Heritage Preserves.

Fortunately, national, state and local historic preservation laws protect the waterway's historic shipwrecks. Likewise, today there is a greater historic preservation ethic practiced by scuba divers who visit the waterway. We can only hope that these French and Indian War relics will retain their structural integrity and be preserved for future generations.

Lake George: Birthplace of the "Modern" American Navy

Published June 15, 2007, Lake George Mirror

There has long been a debate in maritime history as to the birthplace of the American navy. The genesis for this controversy dates to the American Revolution (1775–1783).

Nearby Whitehall, New York, has a strong claim to this title, citing the Continental army's construction of an American fleet on Lake Champlain in 1776 that culminated with the Battle of Valcour (October 11, 1776). However, some argue that this was an army operation and not navy related.

Philadelphians believe that their city deserves the designation of birthplace of the American navy. The Continental Congress, while meeting in Philadelphia, passed a resolution on October 13, 1775, to acquire two armed vessels, from which the Continental Navy grew. The U.S. Navy cites this date as its birthday.

Beverly and Marblehead, Massachusetts, have a strong case, too, for this honor. In late 1775, American patriots outfitted warships to search for armed British transports off New England.

Machias, Maine, points to the seizure of a Royal Navy vessel by a sloop of patriots on June 12, 1775, for its claim as birthplace of the American navy.

Even Providence, Rhode Island, has rights to this nickname. The city was the first to call for the creation of an American navy.

Confusing!

Now, Lake George can argue for a similar crown as birthplace of the "modern" American navy. If you have seen the DVD documentary *The Lost Radeau: North America's Oldest Intact Warship*, you might recall one of its substories about a 1980s-built experimental naval vessel named *Sea Shadow*.

This futuristic ship has revolutionized the design of modern American warships. The *Sea Shadow* has architectural similarities to Lake George's 1758 *Land Tortoise* radeau.

On October 22, 1758, the British deliberately sank the *Land Tortoise* to prevent capture by the French. The shipwreck was discovered in 1990 by Bateaux Below and then studied from 1991 to 1993.

The seven-sided *Land Tortoise* was a British warship of the French and Indian War (1755–1763) and was the prototype for a class of floating gun battery called "radeau" (French for "raft"). The *Land Tortoise* was literally a floating fortress pierced for seven guns. Unique to the radeau was its flat-panel upper bulwarks that tumbled in to protect the vessel's gunners from hillside musket fire. The flat-bottomed, fifty-two-foot-long *Land Tortoise* was built to be an artillery support craft to venture into shallow water and silence enemy fire before an amphibious troop landing.

The radeau design was later used in 1776 on Lake Champlain with the British warship *Thunderer*. In the War of 1812 (1812–1815), the Americans constructed several floating batteries called block ships. During the Civil War (1861–1865), the ironclad CSS *Virginia* had a tumblehome casemate, imitating the design of the *Land Tortoise*.

In the 1980s, the U.S. Navy and Lockheed Martin built a strange-looking 164-foot-long test vessel called *Sea Shadow*. The warship made a quantum leap in technological innovation. Its hull configuration had hard angles with a sloping trapezoidal appearance, a waterborne version of the F-117 stealth aircraft. The top-secret *Sea Shadow* was first unveiled in 1993. When photographs of it became public, researchers with Bateaux Below were stunned by the likeness of the *Sea Shadow*'s hull shape to that of the *Land Tortoise* radeau.

Naval stealth technology and automation for reduced crew numbers, pioneered in the *Sea Shadow*, are now being applied by the modern U.S. Navy.

Bateaux Below's Terry Crandall compared the *Sea Shadow* and *Land Tortoise*:

> *In today's modern navy, that same trapezoidal shape is being used to deflect radar, as that was used by the colonists to deflect perhaps small arms fire or even perhaps grapeshot or small cannon fire. The angled sides, the thickness of the planks and the trapezoidal shape both serve the purpose, generations apart, but served the same purpose of deflecting something.*

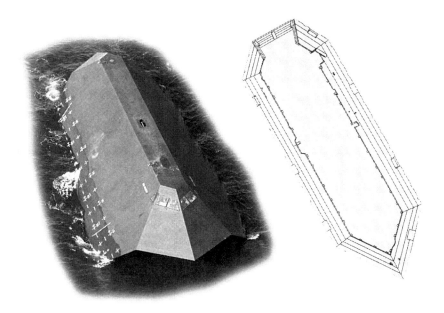

The modern-day American warship prototype, the *Sea Shadow* (left), is similar in shape to the 1758 *Land Tortoise* radeau (right), thus supporting the claim that Lake George is the birthplace of the "modern" American navy. *Courtesy of U.S. Navy & Bob Benway/ Bateaux Below.*

Thus, it seems that Lake George, often called the Queen of American Lakes because of its natural beauty, can now command a new moniker: birthplace of the "modern" American navy.

Reputed 1758 Radeau Shipwreck Artifact Sent to Lake George

Published September 1, 2005, Lake George Mirror

On August 20, 2005, underwater archaeologist Joseph W. Zarzynski received a mystery package delivered by UPS. The cardboard box was from a man living in Pennsylvania. Inside the package were two items: a one-page letter and what the sender described as "a relic with a tag identifying it as coming off the 'French' Radeau Land Tortoise." The sender, a French and Indian War buff living in the Keystone State, wrote that, in the late 1990s while residing in Indiana, he bought the hand-forged

iron chain with an iron hook attached to one end. The Pennsylvania man said he got it from a friend "who deals in military items." The friend claimed to have found it at a "Civil War show." A white tag with several words written in pen—"From the French Radeau the land Tortoise, Sunk in Lake George in 1758"—was tied to the artifact. Now, several years and a few moves later, the Pennsylvania resident sent the artifact to Zarzynski, stating that it is likely that the artifact is not from the radeau, but "if it were from the *Land Tortoise* I would like to see it go back home." Thus began a historical mystery!

The 52-foot-long *Land Tortoise* radeau shipwreck lies in 107 feet of water about two miles north of the Steel Pier at the south end of Lake George. The British warship, a veteran of the French and Indian War (1755–1763), was deliberately sunk by British forces on October 22, 1758, to keep the seven-sided floating gun battery out of the hands of the French. Called "North America's oldest intact warship," the sunken watercraft was discovered by Bateaux Below members on June 26, 1990, during a Klein side scan sonar survey. From 1990 to 1993, an underwater archaeology team studied the historic shipwreck. Then, in 1995, the radeau—French for "raft" but a type of floating gun battery—was listed on the National Register of Historic Places, and three years later, the *Land Tortoise* became only the sixth shipwreck designated a National Historic Landmark. Since 1994, the radeau has been one of the lake's Submerged Heritage Preserves, a state-administered shipwreck park for scuba divers.

Shortly after receiving the package, Zarzynski contacted officials of several state agencies to inform them about the mystery artifact.

The sender, whose name is not being released for privacy reasons, speculated that the metal artifact "appears to have undergone electrolysis?" Electrolysis is a conservation technique to mitigate the corrosion process within iron artifacts. When electrolytic reduction is completed, the iron piece turns dark with stable magnetite, while the iron's harmful anions wash away. However, ferrous objects found in freshwater sometimes are in fairly good shape and do not require electrolysis. Nevertheless, they still require conservation treatment by a skilled conservator.

Zarzynski asked state authorities and conservators to examine the thirteen-inch-long artifact to determine its age and see if it could have come from the radeau shipwreck. A state museum official circulated a photograph of the artifact to museum conservators to get a preliminary analysis. Furthermore, Zarzynski contacted Dr. Bradley Rodgers, a renowned conservator from

French and Indian War Shipwrecks

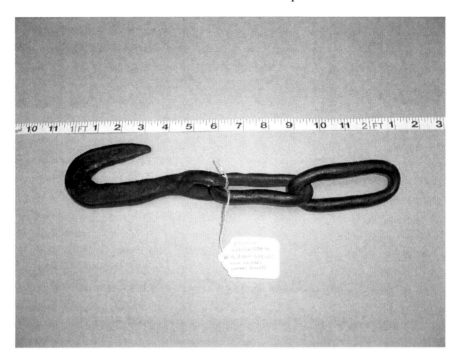

This mystery artifact reputedly came from the 1758 *Land Tortoise* radeau shipwreck. If so, it was removed illegally. It was sent to Bateaux Below and now is in the New York State Museum collection. *Courtesy of Joseph W. Zarzynski/Bateaux Below.*

East Carolina University in Greenville, North Carolina, to get his opinion about the iron relic. In the 1990s, Rodgers did the conservation treatment on three radeau cannon port lids. The wooden lids were recovered by Bateaux Below with state permission and are now in the collection of the New York State Museum.

There are three possibilities for this iron artifact: 1) it is from the eighteenth century and from the radeau, 2) it is an eighteenth-century artifact but is not from the radeau or 3) it is not from the eighteenth century but has been touted as being from the radeau.

If the artifact is from the 1758 *Land Tortoise*, it could have been recovered by a scuba diver while visiting the underwater park. However, removing it without a state permit is illegal.

Regardless of the iron chain's age and where it came from, Bateaux Below members are concerned that an artifact billed as being from the *Land Tortoise* has been apparently sold on the collectors' market. The *Land Tortoise* shipwreck is protected by federal, state and local historic preservation laws.

The illegal removal of artifacts from the shipwreck site is prohibited and is a criminal offense.

Authors' note: Eventually, the reputed radeau artifact was officially received by the New York State Museum in Albany, New York, and regardless of its origin, the artifact is now part of the collection of this world-class museum.

IS SCOUR AN EMERGING SCOURGE AT RADEAU SHIPWRECK?

Published September 22, 2006, Lake George Mirror

The 1758 *Land Tortoise* radeau is arguably the most historic shipwreck in Lake George. The seven-sided British and provincial floating gun battery was designated a National Historic Landmark in 1998 and, more recently, has been brought into people's living rooms with the release of the DVD documentary *The Lost Radeau: North America's Oldest Intact Warship*. However, recent inspection dives to the radeau have revealed an emerging threat to the structural integrity of this watercraft: the little-understood impact of possible scouring at the historic shipwreck.

In 1995, the Smithsonian Institution recognized the *Land Tortoise* as "the oldest intact war vessel in North America." The French and Indian War vessel lies in 107 feet of water. From the second weekend in June through Labor Day, approximately 100 to 150 sport divers register with the New York State Department of Environmental Conservation and dive the underwater park; diving is by permit only. At first glance, the 52-foot-long by 18-foot-wide radeau appears to be incredibly intact. Nevertheless, for the past few years, Bateaux Below divers have been monitoring the growing phenomenon of possible scouring.

Scouring is the erosion of sediment from water flow associated with waves and currents. Scouring at shipwrecks is determined by the orientation of the sunken vessel relative to the flow regime. The flow velocity in fresh water, though generally less intense than that in marine waters, can affect shipwrecks.

When an object, such as a watercraft, is introduced to a seabed or lake bottom, this often leads to an increase in flow velocity at the site. At Lake George, this can manifest itself by the formation of a horseshoe vortex in front of the shipwreck and/or lee wake vortices behind the sunken vessel. Lake George flows north, emptying into Lake Champlain.

French and Indian War Shipwrecks

On September 9, 2006, Bob Benway and Joseph W. Zarzynski, joined by New York State Department of State official Steven C. Resler, dived the radeau; the shipwreck preserve closed to the public on Labor Day. The trio noted an increase in the scour signature to the lee of the radeau, its port side. A follow-up dive to photograph the scour was made on September 17.

The scour signature on the port side of the radeau is approximately 2 to 2.5 feet wide, 1 to 1.5 feet deep and appears to be growing. This trough-like erosion has exposed hull structure that, for nearly 250 years, was embedded into the soft sediment of the lake.

In recent years, Bateaux Below divers have noticed plastic cups, trash tossed into the lake by visitors, lying adjacent to some deepwater wrecks. This litter was snagged by exposed wreck structures, a further indication of the hydrodynamic forces at work in Lake George.

Scour is a threat to the stability of shipwrecks and can accelerate the physical degradation of sunken ships, even leading to the collapse of the structure. On September 13, 2006, Zarzynski met with Charles Vandrei, historic preservation officer for the Department of Environmental Conservation, to brief him.

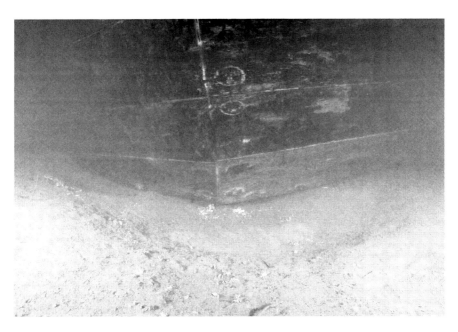

A trough-like erosion signature, possible scouring, in the lake bottom next to the 1758 *Land Tortoise* radeau shipwreck poses concern over the historic preservation of the British warship. *Courtesy of Bob Benway/Bateaux Below.*

Many people have referred to the *Land Tortoise* as a "time capsule," an intact shipwreck that has reached some form of equilibrium with its deepwater environment. It appears, however, that the radeau is in a more dynamic environment affected by a variety of human and environmental forces.

Bateaux Below members and state cultural resource managers are anxious to study the impact of increased flow velocity in the lake that is possibly due to heavy springtime rains and the opening of the sluice gate at the lake's north end. The archaeology team will seek grant funding to support using more remote sensing technology and increased imagery equipment to document this site scouring. Furthermore, options to minimize possible degradation of this historic vessel from scouring will be examined. In the extreme, engineering applications like building deflectors or sandbagging at the site might be a viable management strategy to help preserve North America's oldest intact warship.

NO STATE DESTINATION SIGN FOR THE *LAND TORTOISE* SHIPWRECK

Published July 25, 2008, Lake George Mirror

Eleven months ago, on August 22, 2007, Bateaux Below sent a letter to the Schenectady, New York Region 1 office of the New York State Department of Transportation (NYSDOT), requesting that the agency install "along Route 87 or Route 9 near exit 21 of the Northway…[a] sign [that] would help to inform travelers about an historic shipwreck in Lake George that in 1998 was designated a National Historic Landmark [NHL] by the U.S. Dept. of the Interior." NYSDOT's sign program is responsible for erecting signage along the 16,400 miles of state highways. Bateaux Below's proposal began over a year ago with a telephone inquiry to the Warrensburg NYSDOT office.

The suggested text proposed for the sign read:

Lake George, NY
Site of 1758 LAND TORTOISE
Radeau Shipwreck,
National Historic Landmark

French and Indian War Shipwrecks

On July 15, 2008, the NYSDOT replied to the sign request: "While the *Land Tortoise* is a national historic landmark and is part of a maritime fleet used during the French and Indian War, this site does not generate a significant volume of visitors…it does not warrant the installation of destination signs at this time."

A contributing factor for the justification of the proposed signage was the precedent of a similar road marker located along Route 87 near Plattsburgh, New York. That signboard informs travelers that Plattsburgh Bay, site of the 1814 American-British naval engagement on Lake Champlain during the War of 1812 (1812–1815), is a National Historic Landmark (NHL). Plattsburgh Bay was designated a NHL in 1960.

According to the NYSDOT letter, "Guide signs may be used on our highways when a cultural interest area is a significant destination for the users of our highways." Currently, only about 100 to 150 divers a season register with the New York State Department of Environmental Conservation (NYSDEC) to dive the *Land Tortoise*, a 1758 floating gun battery and an underwater state park. Due to the depth, 107 feet, and the historical significance of the British warship, divers must register with the

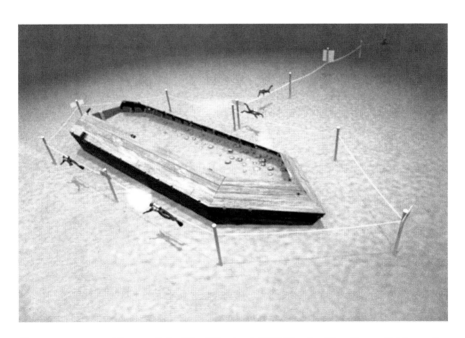

Computer-generated image of the "*Land Tortoise*: A 1758 Floating Gun Battery" shipwreck preserve at Lake George. *Courtesy of John Whitesel.*

NYSDEC before diving the radeau. The wreck is open to divers from the second Saturday in June through Labor Day.

The fifty-two-foot-long radeau is known as North America's oldest intact warship, a description coined by Hague summer resident Dr. Russell P. Bellico, historian and now a retired professor from Westfield State College.

On October 22, 1758, the *Land Tortoise* was deliberately sunk by the British to put the warship into "cold storage" to be retrieved the following year. It, however, ended up in deep water. The radeau was discovered on June 26, 1990, during a Bateaux Below side scan sonar survey.

This year, 2008, marks the 250th anniversary of the vessel's sinking. It is hoped the anniversary would be an ideal time to get the NYSDOT to erect a roadside sign. The *Land Tortoise* is the only radeau-class warship to have ever been found and is one of only two sites at Lake George listed as NHLs. The other Lake George NHL is the Owl's Nest, novelist Edward Eggleston's estate on the lake's east side.

Although Bateaux Below is disappointed with the NYSDOT's stand, the underwater archaeology team is appreciative of the professional manner in which the decision process was conducted.

Ironically, the day after Bateaux Below received the NYSDOT letter, denying the sign application, Plattsburgh's Mountain Lake PBS television station sent a crew to Lake George. The PBS affiliate shot interviews and video footage to promote its upcoming August 6, 2008 television premiere of Pepe Productions' award-winning documentary, *The Lost Radeau: North America's Oldest Intact Warship*. Likewise, on August 14, Troy, New York's WMHT will air the documentary. The public will not soon read a destination sign along the Northway, informing them that Lake George is home of the 1758 *Land Tortoise*, a National Historic Landmark, but they will be able to "visit" the historic shipwreck through the medium of television.

Class Explores Schenectady, New York Connection to Lake George Bateaux

Published November 2008, Lake George Mirror

On October 15, 2008, a class at the Schenectady County Community College (SCCC) in Schenectady, New York, explored that city's connection to Lake George's sunken bateaux of 1758. The class was part of an eight-week

French and Indian War Shipwrecks

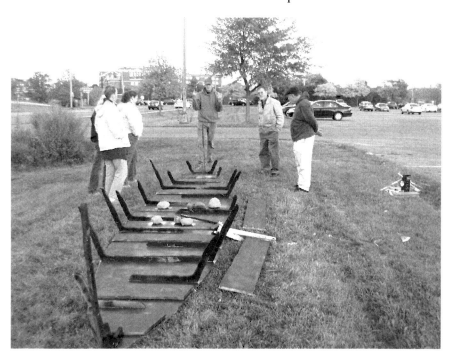

On October 15, 2008, a class at the Schenectady County Community College in Schenectady, New York, explored that city's connection to Lake George's sunken bateaux of 1758 by mapping a twenty-five-foot-long replica model of a bateau wreck. *Courtesy of Pat Meaney.*

course entitled "Shipwreck Archaeology for Non-Divers" and was taught by Joseph W. Zarzynski. The continuing education course provided instruction on techniques to map a shipwreck. A full-scale teaching aid model used in the class was a twenty-five-foot facsimile of an eighteenth-century bateau wreck. It was constructed of rigid insulation boards and was painted brown.

Since the autumn of 2008 marked the 250th anniversary of Lake George's Sunken Fleet of 1758, the class was timely. The Sunken Fleet of 1758 was a historic event where British troops at Lake George deliberately sank 260 bateaux and other types of warships to protect them over the winter from French raiders. Many of those sunken vessels were raised in 1759 and used in British General Jeffery Amherst's military campaign that pacified the Champlain Valley and contributed to a British victory in the French and Indian War (1755–1763).

The model used in the class was based on the archaeological record of one of the three bateaux raised from Lake George in 1960. The typical colonial bateau was twenty-five to forty feet long, flat bottomed, fashioned of pine planks and hardwood frames and was pointed at bow and stern.

According to Dr. Russell P. Bellico's book, *Sails and Steam in the Mountains: A Maritime and Military History of Lake George and Lake Champlain*, bateaux built in Schenectady and Albany during the French and Indian War were used at Lake George. Bateaux constructed in Schenectady were taken east on the Mohawk River to the falls at Cohoes and overland to the Hudson River, and then men rowed them north to Fort Edward. During the war, a fourteen-mile-long military road was cut through the forests from Fort Edward to Lake George. Along this "highway," hundreds of bateaux, many constructed in Schenectady and Albany, were transported on wagons to the lake. Thus, as Lake George recognizes the 250th anniversary of the Sunken Fleet of 1758, special acknowledgement should also be given to the bateau-building "factories" of Schenectady.

The old Schenectady harbor, located where the Binnekill tributary meets the Mohawk River, was a boat-building center during colonial times and into the nineteenth century. Today, those once busy boatyards are covered over by urban sprawl, and the former harbor borders the SCCC campus.

Following the colonial wars, the Schenectady boat-building center underwent a renaissance when the Western Inland Lock Navigation Company opened in 1792. It provided a water route west to Utica, Rome and Oswego, New York. A longer flat-bottomed vessel emerged, too—the Durham boat. Durham boats were forty to sixty feet long and were the watercraft that ferried General Washington's troops across the Delaware River, leading to an American victory over Hessian (German) troops in December 1776. Its design was copied from Pennsylvania, and in northern New York, it became known as the "Schenectady boat."

The recent mapping class on the grounds of SCCC was a reminder of Schenectady's colonial connection to Lake George and the Sunken Fleet of 1758.

Raising the Sunken Fleet, the 250th Anniversary

Published July 24, 2009, Lake George Mirror

July 21, 2009, marked the 250th anniversary of British General Jeffery Amherst's eleven-thousand-man army embarking on 800 warships from the south end of Lake George. The objectives were the north end of the lake and a thrust into the Champlain Valley to pacify the French fortresses

French and Indian War Shipwrecks

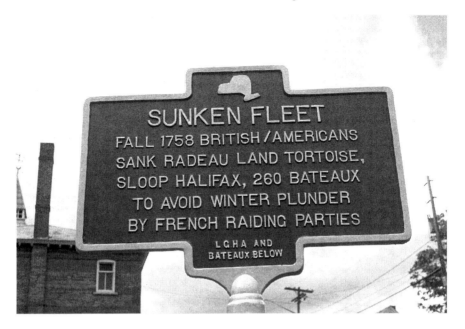

One of the most photographed historical markers at Lake George is the SUNKEN FLEET signage. *Courtesy of Joseph W. Zarzynski/Bateaux Below.*

of Carillon (Ticonderoga) and St. Frédéric at Crown Point. One of the intriguing aspects before the 1759 offensive was that Amherst's men apparently recovered about three-quarters of the 260 British bateaux and other vessels deliberately immersed in Lake George, an event called the Sunken Fleet of 1758.

On this anniversary, it seems appropriate to review the 1759 salvage of part of the sunken fleet and to offer thoughts about the historical records and archaeological investigations pertaining to this feat.

In the autumn 1758, British and colonial American troops at Lake George deliberately sank 260 bateaux, two radeaux (floating gun batteries), some row galleys and other warships. Since the British had no fortification on the lake—in 1757, Fort William Henry was destroyed—this "cold storage" protected the squadron from French raiders over the winter of 1758–1759. Furthermore, in March 1757, a French foray from the Champlain Valley used ice-covered Lake George as a "roadway," and the marauders burned 300 British bateaux and other watercraft lying on shore.

In 1960, the region was introduced to the Sunken Fleet of 1758 when two teenage scuba divers found several bateau wrecks. That year,

three bateaux were raised from the lake and were taken to Adirondack Museum. Following conservation treatment, one was exhibited there for three decades. From 1963 to 1964, Terry Crandall, an archaeological diver with the Adirondack Museum, mapped bateau shipwrecks. Then, in 1987, Bateaux Below was formed to study the Sunken Fleet of 1758, a project that still continues today.

Several things are known about the sunken bateaux. The remnants of over forty articulated and disarticulated bateaux have been located in the lake. They are in poor shape. Most of the side planking (strakes) fell off after the metal fasteners (nails) rusted. Many bateaux were damaged, too, in the 1960s by souvenir-seeking scuba divers. However, several bateaux retain 30 to 40 percent of their structural integrity, mostly bottom boards, some frames and garboard strakes. The shipwrecks are in several clusters, a deliberate strategy by the British for easy recovery.

It is possible that the submerged warships were marked in 1758 with crude floats, as Crandall found some wooden buoys in his 1963–1964 fieldwork. However, lake historian Dr. Russell P. Bellico says that he has uncovered no archival references supporting that.

Most bateaux were loaded with rocks to sink them in 1758. Perhaps the initial attempts to retrieve the bateaux in 1759 began with soldiers trying to pull the rock-laden submerged vessels to shore using block and tackle or teams of work animals. This "muscling" of shipwrecks undoubtedly led to the stem, a bateau's forward timber, being dislodged. The British probably eventually discovered a better method of raising their boats, possibly the limited use of free divers to remove rocks and then grappling hooks to lift the boats. Whatever their methodology, it worked, since over two hundred sunken bateaux are not in the lake, likely recovered and used by Amherst's army in 1759.

Underwater archaeologists may one day gain more insight into how eighteenth-century soldiers with rudimentary engineering recovered much of their sunken armada. Until then, we can only marvel at how they retrieved their waterlogged craft, warships that propelled them to victory in the French and Indian War.

Twentieth Anniversary: Discovery of 1758 *Land Tortoise* Radeau Shipwreck

Published June 18, 2010, Lake George Mirror

June 26, 2010, marks the twentieth anniversary of the discovery of the 1758 *Land Tortoise* radeau shipwreck, a French and Indian War vessel in Lake George. The discovery of this one-of-a-kind, seven-sided floating gun battery was made during a Klein side scan sonar survey. At the time, the discovery team—Joseph W. Zarzynski, Bob Benway, Vincent J. Capone, John Farrell and Dave Van Aken—knew the find was significant. Following the 1990 discovery, Lake George historian Dr. Russell P. Bellico dubbed the fifty-two-foot-long vessel North America's oldest intact warship. So, on the twentieth anniversary of this find, a review of what has since transpired is fitting.

Following the discovery, team leader Zarzynski and others met with State of New York officials and eventually secured a permit to conduct an archaeological investigation. Without major funding, Bateaux Below fortunately enlisted the help of Dr. D.K. Abbass, a Rhode Island resident, who became project archaeologist. The Lake George Historical Association donated a meeting room for the project. Rensselaer Fresh Water Institute, today called Darrin Fresh Water Institute, donated housing for out-of-area volunteers. From 1991 to 1993, the volunteer archaeology team mapped the radeau (French for "raft"), lying in 107 feet of water. In 1994, the team then set the site up as a shipwreck preserve. It has been estimated that nearly $1 million of donated services went into the underwater archaeology project.

In 1994, Bateaux Below released a groundbreaking image, a seamless photomosaic of the radeau. Benway was photographer for the photomosaic, and Kendrick McMahan, a New Jersey resident, did the computer assemblage. The photomosaic took over nine hundred hours to complete, funded by a $2,500 grant from the Lake Champlain Basin Program with $34,000 in donated services. Using two hundred photographs, this was the first-ever seamless photomosaic of a shipwreck. McMahan used a relatively new computer software program for the radeau photomosaic assemblage: Photoshop.

In August 1994, the radeau opened to divers, part of the underwater park called Submerged Heritage Preserves, administered by the Department of Environmental Conservation.

In 1995, the *Land Tortoise* was listed on the National Register of Historic Places. More importantly, in 1998, the 1758 radeau shipwreck was designated a National Historic Landmark. Only five other wrecks have that recognition: Civil War vessels *Monitor* and *Maple Leaf*, the Spanish-American War's *Antonio Lopez* and World War II battleships *Arizona* and *Utah*.

The radeau has also been featured on local signage. In 1993, the Lake George Historical Association and Bateaux Below erected a blue and yellow metal marker behind the Old Courthouse Building. Entitled SUNKEN FLEET, it includes a reference to the *Land Tortoise*. In 1995, a blue and yellow marker—RADEAU WARSHIP—funded by Bateaux Below, was installed at Million Dollar Beach at the south end of the lake. In May 1999, the New York State Department of Environmental Conservation, with assistance from the U.S. Department of the Interior and the New York State Office of Parks, Recreation and Historic Preservation, erected a granite marker with bronze plaque on shore, just west of Million Dollar Beach.

In 2005, Glens Falls, New York's Pepe Productions, a multi-media company, released a fifty-seven-minute-long DVD documentary on the

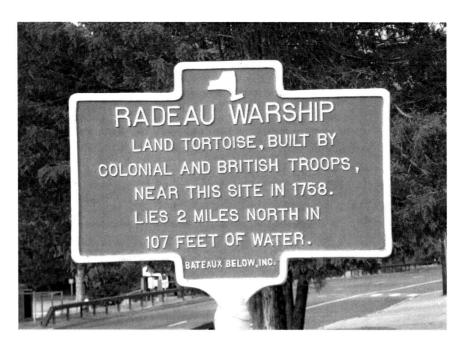

This blue and yellow historical marker, RADEAU WARSHIP, was erected at the south end of the lake in 1995 to inform people about this shipwreck in Lake George. *Courtesy of Bob Benway/Bateaux Below.*

French and Indian War Shipwrecks

history and archaeological study of the *Land Tortoise* radeau. Written by John Whitesel and Zarzynski, *The Lost Radeau: North America's Oldest Intact Warship* (www.thelostradeau.com) has won three national awards for video excellence, been featured in two film festivals and has been shown on PBS television.

The radeau, likewise, has been in numerous articles and several books, most notably *Sails and Steam in the Mountains: A Maritime and Military History of Lake George and Lake Champlain* by Dr. Russell P. Bellico.

In 2008, Bateaux Below petitioned the New York State Department of Transportation to erect a sign along Route 87. The proposed text read:

Lake George, NY
Site of 1758 LAND TORTOISE
Radeau Shipwreck,
National Historic Landmark

Unfortunately, the request was denied by the New York State Department of Transportation, stating the 1758 *Land Tortoise* radeau shipwreck is not

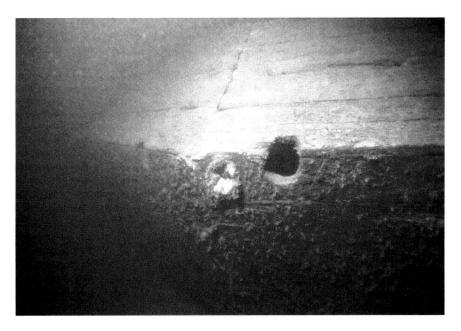

This underwater photograph shows the 1758 *Land Tortoise* radeau shipwreck, a vessel dubbed North America's oldest intact warship. *Courtesy of Dr. Russell P. Bellico/Bateaux Below.*

"a cultural interest area [that] is a significant destination for the users of our highways."

Recently, Bateaux Below contacted the British Embassy in Washington, D.C., to begin sharing information on the *Land Tortoise*. It is hoped this will aid in managing the iconic warship.

For two decades, Bateaux Below and other volunteers have made frequent scuba visitations to inspect the radeau, presented hundreds of lectures and donated thousands of hours toward the shipwreck's preservation. However, as Bateaux Below members age, it will be a challenge to forge new alliances to ensure that the radeau continues to be preserved, thus living up to its nickname as North America's oldest intact warship.

Chapter 3
NINETEENTH-CENTURY SHIPWRECKS

Saluting Bolton's *Cadet* Steam Launch Shipwreck

Published June 3, 2005, Lake George Mirror

On November 8, 1997, Bateaux Below members discovered a mysterious wreck lying in Lake George off the town of Bolton. The Klein 2000 side scan sonar that was used to find the shipwreck was provided by Vincent J. Capone, a sonar expert and member of Bateaux Below. Several days after the discovery, a dive team from Bateaux Below "ground truthed" the sonar target. The group had found a previously unknown shipwreck, the *Cadet*, a forty-eight-foot-long, 1893-built wooden steam launch. That find began the multi-year process of studying and interpreting the vessel, possibly the best-preserved shipwreck of its class found in the northeastern United States. Now, over seven years later, the story of this historic vessel, instrumental in the development of Lake George as a resort-era destination, is being told by a variety of interpretive outlets.

The *Cadet* was built in 1893 at the north end of Lake George and was originally named *Olive*. Its owner, N.E. Porter, soon sold the *Olive* to Captain Raphael Potter. It ran as an excursion boat and also carried supplies to hotels around the lake.

In 1898, the vessel was acquired by John Boulton Simpson, one of the founders of the Sagamore Hotel on Lake George in Bolton Landing, New

York. He lengthened and rebuilt the *Olive* and then renamed it *Cadet*. In 1899, the *Cadet* hung up on Gull Rock, and the vessel had to be pulled off by the steam yacht *Vanadis*. Simpson, apparently not too satisfied with the vessel, sold it. By 1901, the *Cadet* was operated by Bolton Landing's captain Fred R. Smith. The steam launch was advertised as one of Smith's "finely equipped launches for charter by day or week," and it operated for several years. However, the *Cadet* eventually disappeared from the historical record, a victim of age and an emerging technology, gasoline-powered vessels. Apparently the *Cadet* was stripped of its major equipment, taken to deep water and then scuttled.

In 1999, Bateaux Below conducted a twenty-five-day archaeological study of the shipwreck, completed entirely by volunteers since the group was unable to acquire funding. The archaeological investigation determined that the *Cadet* is a 48.0-foot-long by 9.6-foot-wide wooden-hulled steam launch. It has a pointed bow, rounded bilges and a fantail stern. The watercraft's hull is intact, but the *Cadet* has some damage to its stern. Coal found inside the boat was later identified by a Pennsylvania laboratory as stoker egg anthracite from Lackawanna County, Pennsylvania.

From 2001 to 2002, Bateaux Below worked with the New York State Office of Parks, Recreation and Historic Preservation to nominate the *Cadet* shipwreck to the National Register of Historic Places. In 2002, the *Cadet*

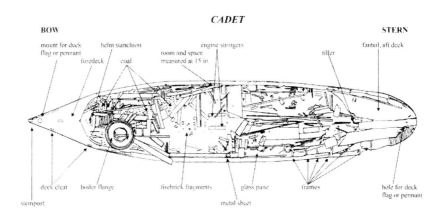

This is a plan view drawing of the 1893-built *Cadet* shipwreck based on the archaeological record. *Courtesy of Bob Benway and Joseph W. Zarzynski/Bateaux Below.*

Nineteenth-Century Shipwrecks

No photograph of the 1893-built *Cadet* ex *Olive* steam launch has ever been found. This drawing, based on the archaeological record, shows how the vessel possibly looked. *Courtesy of Mark Peckham.*

was listed on the National Register; other Lake George shipwrecks on this registry are the seven 1758 wrecks called the Wiawaka Bateaux Cluster (listed in 1992) and the 1758 *Land Tortoise* radeau (listed on the National Register in 1995 and designated a National Historic Landmark in 1998). In the spring of 2005, a blue and yellow historic marker entitled CADET SHIPWRECK will be erected in Bolton Landing's Veterans Park.

It will read:

CADET SHIPWRECK

BUILT 1893 AS STEAM LAUNCH
OLIVE, RENAMED CADET. SUNK
OFF BOLTON, DATE UNKNOWN.
LISTED ON NATIONAL REGISTER
OF HISTORIC PLACES IN 2002.

BATEAUX BELOW

The signage cost $786.

Bateaux Below and a local multi-media company, Pepe Productions, have also produced a twenty- by thirty-inch full color poster entitled "Lake George's Historic *Cadet* Steam Launch." The two-dimensional exhibit describes the history of the watercraft and the results of the 1997–1999 archaeological

fieldwork. Copies of the poster will be donated to the Historical Society of the Town of Bolton, the Sagamore Resort and to the Town of Bolton.

Four years ago, a copy of the research team's report on the underwater archaeology survey of the *Cadet* was donated to the Historical Society of the Town of Bolton, the Crandall Library and other repositories. Members of the archaeology team have, likewise, presented numerous local lectures and also given professional papers at state, regional and national archaeology conferences.

On May 7, 2005, Bateaux Below divers inspected the *Cadet*, an annual ritual made by the group. The team reported the historic watercraft remains in good condition, almost regal in appearance.

The *Cadet* ex *Olive* steam launch underwater archaeology project has been a grass-roots endeavor. It shows how underwater archaeology can uncover and exhibit a previously little-known chapter of Lake George's past.

"Old Time Barge" Relocated by Underwater Archaeological Team

Published May 28, 2004, Lake George Mirror

Maritime historians and underwater archaeologists often scan microfilm readers researching shipwreck stories from old newspapers. Many years ago, Dr. Russell P. Bellico, a trustee of Bateaux Below, discovered a 1959 article of the *Lake George Mirror* entitled "Divers Discover Old Time Barge, Bottom of Northwest Bay." The news story was about a dozen "Connecticut skin divers" who visited Lake George and located "what appeared to be a 60-foot barge of antique design." These intrepid explorers said the sunken watercraft was "covered with a foot or two of clay." The shipwreck then disappeared from the literature record. With that news article, the "Old Time Barge" became part of the lore of the lake, and for years, it was on Bateaux Below's list of shipwrecks to find and inspect.

In 1988, principals of the group that became Bateaux Below initiated a project to inventory the lake's sunken bateaux that were used during the French and Indian War (1755–1763). That inventory endeavor soon expanded to include all types of shipwrecks in the lake and even other submerged cultural resources such as sunken docks and marine railways.

Nineteenth-Century Shipwrecks

Yet, with every year that passed that the "Old Time Barge" was not relocated, its stature grew. Was it a colonial vessel? Was it as long as reported? What was the function of the watercraft?

Over the years, Bateaux Below has conducted several side scan sonar surveys and made numerous reconnaissance dives in Bolton waters, trying to find the mysterious sunken vessel. Although numerous shipwrecks were discovered, surprisingly no barge like the one described in the 1959 article was detected.

Finally, on August 28, 2003, the legendary shipwreck was located during a Klein 3000 side scan sonar search undertaken by Bateaux Below. The 2003 survey was financed by a $3,000 grant from the Fund for Lake George, Inc. The fieldwork was done over a fifteen-day period, with two days of side scan sonar surveying and thirteen days of scuba diving to ground truth side scan sonar-generated targets and also to conduct diver reconnaissance. The 2003 project resulted in the discovery of one wooden barge, one wooden sailboat, three wooden runabouts, one abandoned fuel tank, one pram (rowboat) and fourteen log clusters, the latter bound for a sawmill. Furthermore, two shipwreck-like targets found by side scan sonar in 2003 need to be reconnoitered to classify them.

The barge wreck, either late nineteenth century or early twentieth century, was located largely because of recent advances in side scan sonar technology with the emergence of the Klein 3000 system. Side scan sonar is a remote sensing device that images the bottomlands of waterways and is the equipment of choice to find sunken ships. It was a Klein 595 that was used in 1990 to discover the 1758 *Land Tortoise* radeau, a seven-sided floating gun battery sunk northeast of Tea Island.

On September 8, 2003, Bateaux Below divers examined the barge-like sonar target. The reconnaissance dive determined it was the reputed shipwreck described nearly forty-five years earlier in the *Lake George Mirror*. Furthermore, the team collected underwater photography and video, as well as measurements of the wooden vessel.

It turned out the "Old Time Barge" was not the 60-foot-long shipwreck the Connecticut skin divers described. Without tape measure and slate, tools of an underwater archaeologist, they undoubtedly overestimated the length of their submerged find. In reality, the rectangular-shaped vessel was 34.5 feet long by 9 feet wide. It held no ore, coal or cargo but had several inches of sediment overburden. A tree rests over the shallow end of the wooden wreck. The lightly framed barge has a raked bow and stern, with its sides surprisingly only 2 feet high.

A drawing in plan view of the "Old Time Barge" found in Bolton waters of Lake George during a Klein side scan sonar survey in 2003. *Courtesy of Joseph W. Zarzynski/Bateaux Below.*

The "antique design" watercraft probably was on the lake in the late nineteenth or early twentieth centuries, possibly engaged in moving lumber from a mill or transporting supplies around to the lakeshore cottages or hotels during the era of the "Great and the Gracious." These barges were the utilitarian workboats of their time. This vessel was not stately in appearance like its contemporaries, steam-powered or early gasoline-powered excursion boats. Nevertheless, this "Old Time Barge" played a significant role in the lake's history when Lake George was emerging as a vacation destination in the Northeast.

Has the Steam Yacht *Ellide* Been Found?

Published November 2004, Lake George Mirror

The celebrated Lake George steam yacht *Ellide* was once described as the fastest vessel afloat, having hit a world speed record of 40.2 miles per hour. Following a noteworthy career as a personal yacht and later a cruise boat, the *Ellide* was reportedly taken from its Bolton Landing boathouse and dismantled. Four years ago, on November 19, 2000, Bateaux Below archaeological diver Bob Benway and underwater archaeologist Joseph W. Zarzynski discovered the disarticulated structural remains of a wooden shipwreck they believe to be the historic watercraft *Ellide*.

Nineteenth-Century Shipwrecks

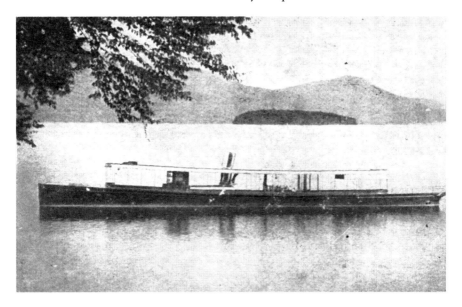

The *Ellide* was the fastest steam yacht on Lake George during its day. *Courtesy of Bob Benway Collection.*

The *Ellide* was constructed in 1897 for Green Island summer resident E. Burgess Warren, one of the owners of the Sagamore Hotel in Bolton Landing. The sleek and speedy steam yacht replaced Warren's slower steam launch, the fifty-two-foot-long *Cyric*. The *Ellide*, designed by Charles D. Mosher, was built in Nyack, New York, at a cost of $30,000. The vessel measured eighty feet overall with an eight-foot, four-inch beam. Its draft was three feet, six inches. The mahogany-planked vessel was originally powered by an eight-hundred-horsepower, quadruple expansion steam engine. According to the *New York Times*, during speed trials on the Hudson River in 1897, the steam yacht covered the distance of a measured mile in one minute, thirty-five seconds.

The month after the tragic sinking of the battleship USS *Maine* in Havana, Cuba, the March 10, 1898 issue of the *New York Times* reported that the *Ellide*'s designer, at the request of then assistant secretary of the navy Theodore Roosevelt, filed sketches of what the *Ellide* would look like as an armored warship. Apparently the Navy Department contemplated purchasing the steamboat for torpedo boat service, as a declaration of war with Spain was imminent. However, according to historian Dr. Russell P. Bellico, the "*Ellide* never apparently entered the U.S. Navy."

At Lake George, the swift vessel was used by Warren for fishing trips and excursions and was often decorated during regattas. Warren was an innovative businessman. The *New York Times* reported that the Philadelphia native "was the first man to give an order to Thomas A. Edison for incandescent lights in a large hotel." Furthermore, Warren was the vice-president of the Barber Asphalt Company when the first asphalt pavement was put down in New York City.

In its latter years at Lake George, Captain W.W. Burton owned the vessel. He operated it as a commercial watercraft. According to Bellico, Burton even replaced the *Ellide*'s power station with a Kermath marine engine. The *Lake George Mirror* reported on July 21, 1923, that the "speed yacht '*Ellide*'" made short excursion trips for its passengers "about the head of the lake."

Over the vessel's long career, it did undergo some structural and cosmetic alterations and repair before the *Ellide*'s final demise. No longer the grand vessel of the lake, the *Ellide* was unceremoniously broken up and scrapped, with part of the historic watercraft sunk in Bolton waters.

On October 10, 2004, Benway and Zarzynski revisited the shipwreck that may be the *Ellide*. Benway used a custom-built camera frame that he designed

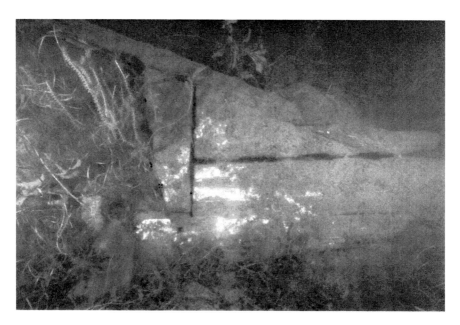

This underwater photograph shows part of the stern of a shipwreck believed to be the steam yacht *Ellide*. *Courtesy of Bob Benway/Bateaux Below.*

with a Nikonos V underwater camera and dual strobe lights to photograph the wreck. What is left of the historic vessel lies in two sections. One part of the wreck measures thirty-seven feet, nine inches long and includes the partially intact bow, about half the length of the keel, part of the keelson, some strakes (exterior hull planking) and even a wooden crosspiece that could be a floor timber or deck support. The other nearby section is the stern. It includes the sternpost, part of the keel and keelson and deadwood.

Benway and Zarzynski hypothesize, based on the shipwreck's location, the length and size of the surviving wooden structure and the shape of the vessel's bow and stern, that the wreck remnants are that of the *Ellide*. Historic preservation laws protect the shipwreck.

The *Minne-Ha-Ha* Steamboat Wreck: A Mystery Recently Uncovered

Published September 8, 2006, Lake George Mirror

Shipwrecks sometimes are not so much due to a single event but rather the result of cultural and natural processes over a protracted period of time. Such is the case of Lake George's *Minne-Ha-Ha (I)*, a nineteenth-century steamboat whose destruction is, in many respects, like the strange death of Rasputin, the "Mad Monk" and mystic during the reign of Russian tsar Nicholas II.

Rasputin, an advisor to the Romanov family in imperial Russia during the early twentieth century, was reportedly killed after several assassination attempts that included being poisoned, shot three times and badly beaten before he was thrown into a river, where he drowned. Following Rasputin's burial, his body was dug up and burned.

The *Minne-Ha-Ha (I)*'s demise was surprisingly somewhat similar. The 140-foot-long paddle wheel steamer was launched on May 12, 1857. Its engine and boilers were pulled from the wreckage of the steamboat *John Jay* that caught fire off Hague the previous summer. The *Minne-Ha-Ha (I)* carried up to four hundred passengers; it was retired after a two-decade career as an excursion steamboat. The wooden behemoth was then towed to Black Mountain Point, on the east side of the lake, where it was converted into a hotel and restaurant. On April 21, 1889, the Horicon Pavilion, a hotel at Black Mountain Point, was destroyed by fire, and the nearby steamboat turned hotel and eatery was closed.

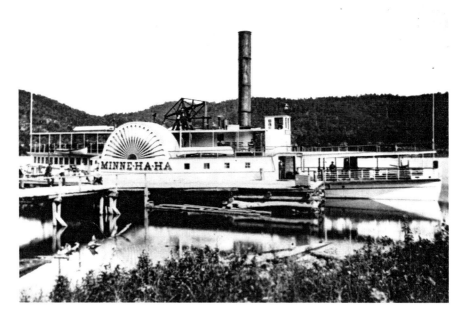

The *Minne-Ha-Ha (I)* was one of Lake George's legendary vessels, and it had a long history on the lake. *Courtesy of Bob Benway Collection.*

The July 8, 1893 *Lake George Mirror* reported: "The old steamer Minnehaha, or what remains of it, lies behind the point at Black Mountain Pier. The storms and ice are fast causing the craft to fall into ruin, and it will not be very many years before the boat totally disappears."

A decaying hulk and a hazard to boats, the old steamboat's upper works were dismantled, and its hull was dynamited to clear the bay where it was abandoned.

However, it appears that the *Minne-Ha-Ha (I)* wreck lies not in a single site. Recently, it has been determined that a section of the disarticulated remains of the *Minne-Ha-Ha (I)* is found a half mile away from the bay at Black Mountain Point, undoubtedly transported there by waves and wind as the steamboat slowly expired. On October 8, 2005, James Sears, president of the New York State Divers Association (NYSDA), informed Bateaux Below of the discovery of part of an old vessel located on a limestone outcropping in the lake.

On November 6, 2005, Bob Benway and Joseph W. Zarzynski dived the wreckage located by Sears and his NYSDA colleagues. The shipwreck timbers were measured and photographed. The section of shipwreck measured nineteen feet, eight inches long by seven feet, four inches wide.

Nineteenth-Century Shipwrecks

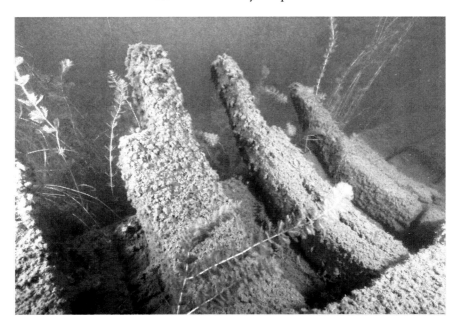

This underwater photograph shows the skeletal remains of the *Minne-Ha-Ha (I)* shipwreck lying in a bay off Black Mountain Point on the east side of Lake George. *Courtesy of Bob Benway/Bateaux Below.*

In September 2006, Bateaux Below members returned to the limestone reef to acquire more photographic documentation of the sunken structure. The team also dived the shallow-water shipwreck remains of the *Minne-Ha-Ha (I)* in the bay off Black Mountain Point to examine and photograph its submerged hull structure, including the keelson and some frames. The dives revealed that the wooden wreckage resting on the limestone outcropping mid-lake is probably from the upper work of the *Minne-Ha-Ha (I)*. This wreckage is even painted white on one side, the primary color of most of the vessel.

This shipwreck inventory fieldwork was supported by a $3,000 grant from the Fund for Lake George, Inc., and from royalties from the sale of the DVD documentary *The Lost Radeau: North America's Oldest Intact Warship*.

The discovery of this wooden structure, most likely from the *Minne-Ha-Ha (I)*, is a reminder that underwater archaeology is often a detective pursuit, following clues to solve the whodunit. Possibly future scuba and remote sensing exploration of the lake between the primary wreck site and the reef remains will uncover more secrets about the Rasputin-like steamboat that refused to die!

Chapter 4
TWENTIETH-CENTURY SHIPWRECKS

Seventy-Five-Year-Old Shipwreck Found and Identified

Published May 21, 2004, Lake George Mirror

Seventy-five years ago, the nation's most popular newspaper, the *New York Times*, described the Lake George motorboat mishap as a "blazing launch" that sank less than ten minutes after catching fire. This incident, the most dramatic boating accident of its time at the lake, is now revisited. With this article, the not-for-profit corporation Bateaux Below announces the shipwreck discovery and identification of the tour boat *Miss Lake George*.

The thirty-five-foot-long wooden watercraft plied the waters of the Queen of American Lakes during the latter years of the Roaring Twenties. Then, on July 21, 1929, the vessel, which operated from a berth at the south end of the waterway, burst into flames about twenty minutes into its cruise. The fire was reportedly caused by "a short circuit and a backfire of its motor."

Fortunately, disaster was averted. The ten passengers and the vessel's pilot, Harmel Burton, were rescued by two boats, the excursion boat *Forward*, operated by Alden Shaw and Leonard Irish, and *The Sea Sled*, owned by Leon Staats. Harmel Burton was the son of Arthur Burton, owner of the *Miss Lake George*. The twenty-two-year-old pilot battled the conflagration with a fire extinguisher, while passengers donned life preservers and jumped

into the water. One passenger, an unidentified woman, had to be forced into the water by the pilot. There were no major injuries, but some passengers lost clothing and small amounts of money. *Miss Lake George* had a top speed of thirty-eight miles per hour and was valued at $5,000 to $7,000. It had been in service on the lake for two seasons.

The shipwreck was found in deep water in the lake's southern basin on May 17, 2002, during a side scan sonar survey conducted by Bateaux Below. The survey team was composed of Vincent J. Capone, John Farrell and Joseph W. Zarzynski. The group used a Klein 2000 side scan sonar integrated with global positioning system and navigation software to locate the historic wreck. The sonar survey was part of a multi-year project to locate all the lake's shipwrecks and other submerged cultural resources. The fieldwork was supported by a small grant from the Fund for Lake George, Inc.

During a May 27, 2002 dive to the site, Bateaux Below divers measured the shipwreck at thirty-five feet long and observed that the vessel's sinking was due to a catastrophic fire. Based on initial research by Dr. Russell P. Bellico, the wreck was tentatively classified as an Albany Boat Corporation vessel. However, none of the books about Lake George vessels included a reference to a shipwreck of this type, length and era.

The Albany Boat Corporation had been located in Watervliet, New York, and was operated by John L. Hacker and Leon L. Tripp. The company constructed wooden runabouts and cruisers, including the presidential yacht of Woodrow Wilson. The Lake George vessel *Show Me III*, owned by William K. Bixby of Bolton Landing, was likewise built by this company. The firm, however, closed its Watervliet factory in 1932.

Following the 2002 discovery of the shipwreck, an archival search was conducted to identify the vessel. It was, however, not until three months ago that the exhaustive research finally paid off. In February 2004, Zarzynski found a 1929 article in the *New York Times* about a thirty-five-foot excursion boat that sank in deep water in Lake George. That archival find directed the team to local news articles that provided more details about the accident.

During a dive in early May 2004, Benway and Zarzynski reexamined the shipwreck. The archaeological team noted that approximately 70 percent of the hull structure had been burned away. The only parts of the vessel that remain are the cutwater, engine, the deck and transom aft of the passenger seats, the starboard gunwale, part of the port gunwale and some of the lower hull structure. The vessel was the victim of a blaze that engulfed it until most of the hull was burned away, and then the weight of the engine sank the boat.

Twentieth-Century Shipwrecks

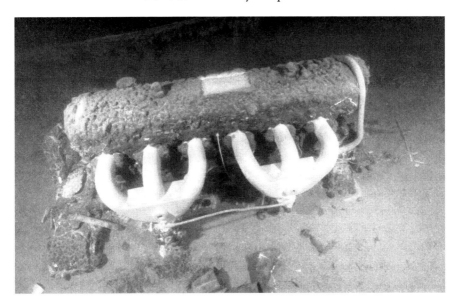

This underwater photograph is of the *Miss Lake George* shipwreck with its gasoline engine still intact. The vessel caught fire and sank in 1929. The historic shipwreck was discovered in 2002 during a Klein side scan sonar survey. *Courtesy of Bob Benway/Bateaux Below.*

One local newspaper reported the *Miss Lake George* was equipped with a two-hundred-horsepower "Hallstock motor." The engine was actually a Hall-Scott engine manufactured by two Californians, Elbert J. Hall and Bert C. Scott. Based upon the scuba inspections, it was determined the vessel did have a Hall-Scott engine with six cylinders, an overhead camshaft and updraft carburetors. During this era, it was common for boats with updraft carburetors to leak gas fumes into the bilge that could be ignited by a short circuit or backfire of the engine.

Though a historic shipwreck and protected by preservation laws, there are no plans to nominate it to the National Register of Historic Places or to make it a shipwreck preserve for divers.

The majestic *Miss Lake George* was a product of the Roaring Twenties, a period of prosperity and optimism for many Americans. The craft's unexpected demise on July 21, 1929, was a harbinger for the stock market crash three months later on October 29, 1929. On that date, Black Tuesday, the nation's economy and the dreams of its populace collapsed like a sinking vessel into the Great Depression.

THE *SCIOTO* SHIPWRECK: INVESTIGATING THE STABILIZATION OPTION

Published June 11, 2004, Lake George Mirror

Underwater archaeology is the study of the past through the examination of submerged cultural resources like shipwrecks, sunken marine railways and inundated waterfront structures. An important component of underwater archaeology is cultural resource management, the administration of underwater heritage sites so they are preserved for future generations. One of the more dramatic options of submerged cultural resource management is the action to minimize the physical deterioration of a shipwreck.

One Lake George shipwreck whose structural deterioration has been accelerated is a submerged wooden watercraft once known as the "copper spike wreck." However, more recently Dr. Russell P. Bellico, author of *Sails and Steam in the Mountains: A Maritime and Military History of Lake George and Lake Champlain*, identified the wreck as the *Scioto*. For decades, scuba divers have visited this site located off an island near Diamond Point.

The seventy-five-foot-long *Scioto* was a turn-of-the-century wooden steamboat that was later converted to gasoline power. The fifty-passenger

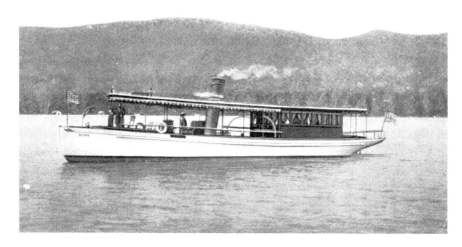

The *Scioto* was a popular Lake George excursion boat in the first half of the twentieth century. *Courtesy of Bob Benway Collection.*

cruise boat, operated by Captain Frank Hamilton of the Kattskill Bay Line, made regular excursion trips around the lake. Years later, the aging tour boat was acquired by Paul Goodness. However, six decades ago, at the end of the vessel's career, the *Scioto* was reportedly unceremoniously scuttled.

Bateaux Below underwater archaeologists have visited the historic shipwreck numerous times to marvel at the wooden skeleton lying in shallow water. It was not, however, until August 3, 2003, during a dive near the site for a mollusk study conducted by Darrin Fresh Water Institute scientists that a Bateaux Below member noticed that the structural integrity of the *Scioto* shipwreck was deteriorating rapidly due to environmental and human impact. This was again noted during a dive on May 30, 2004.

The shipwreck lies in seven to nine feet of water along a southwest–northeast centerline with its bow pointed northeast. The lake bottom here is sandy. A narrow log lies under part of the starboard side, possibly used by souvenir hunting divers trying to gain leverage to move the vessel's starboard hull structure. Forty-nine feet of the vessel's seventy-five-foot length survives. It lies in four pieces broken along the vessel's centerline and also at the turn-of-the bilge on both its port and starboard. What remains of the historic vessel are its hull timbers. Its engine and other hardware are missing. The

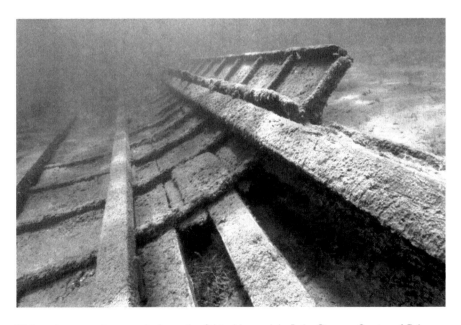

This underwater photograph shows the *Scioto* shipwreck in Lake George. *Courtesy of Bob Benway/Bateaux Below.*

starboard side of the shipwreck still has deck planking attached to the strakes (hull planks).

Since it lies in shallow water, the structural integrity of the *Scioto* is susceptible to surface waves that fan the hull timbers back and forth, rubbing against the sandy lake bottom. This has created a scouring under the port side so that this part of the vessel is not fully supported by terra firma. These invasive waves, combined with a corrosive lake bottom, act like sandpaper that will eventually weaken the remaining articulated hull structure and possibly collapse the port side of the watercraft.

The *Scioto*'s location in a dynamic wave zone and lying on a sandy bottom dictates that preservation intervention may be necessary to decelerate the structural deterioration of the shipwreck. There is precedent for this proactive measure. In 1996, the Great Lakes Shipwreck Preservation Society was formed "as an instrument to stabilize and restore…deteriorating shipwrecks of the Great Lakes region." Closer to Lake George, the Lake Champlain Maritime Museum recently did repair work on the *O.J. Walker* canalboat wreck, one of Lake Champlain's shipwreck preserves. Such repair work can range from the unsophisticated use of sandbags to more intricate strategies like the application of polythene sheeting, geotextiles, resins and more.

Bateaux Below will examine the feasibility of stabilizing the *Scioto* shipwreck to arrest further site degradation. This could involve backfilling the scouring under the port hull timbers or placing sandbags adjacent to sections of the wreck to deflect the impact of wave action and boat wakes that currently damage the shallow-water shipwreck. Sandbags could likewise be used to partially berm or cover part of the hull structure. Local and state cultural resource managers would have to approve any proposed intervention. It is likely, however, if stabilization efforts are not conducted, that the *Scioto* will undoubtedly waste away to a pile of disarticulated boards.

Outboard Racing Boat Discovered During Sonar Survey

Published August 20, 2004, Lake George Mirror

It was possibly home built, a close imitation of the undersized but popular outboard racing boats that ran in races in Hague in the 1950s and 1960s. On May 13, 2004, Bateaux Below discovered this small yet unusual shipwreck

in Lake George. Identified as BBI-164, after its site designation, the sunken watercraft apparently went down under duress rather than through abandonment. The vessel is fully intact and thus provides a window to the past to reexamine an era when "speed was king" at Lake George.

Even before the first Evinrude outboard engine hit the national market in 1909, outboard racing was being done on waterways around America. After World War II, Mercury Corporation led the way in powering diminutive watercraft when it began manufacturing lightweight outboard engines that ran on gas and oil. In the 1930s, outboard-powered racing came to Lake George, and it was quite popular in the '50s and '60s. These small boats often hit speeds from thirty-five to sixty miles per hour.

BBI-164 is a wooden outboard racing craft that was found in Town of Bolton waters during a Klein 3000 side scan sonar survey conducted by Bateaux Below. For the past several years, this underwater archaeology group has been conducting a multi-year project to inventory all the lake's shipwrecks and other submerged cultural resources. The small racer was one of several shipwrecks found during side scan sonar fieldwork conducted over a three-and-a-half-day period in mid-May 2004.

This year's sonar project, reconnaissance diving and archaeological recording are supported by a $3,000 grant from the Fund for Lake George, Inc. Barkentine, Inc., a Pennsylvania-based remote sensing company owned by Vincent J. Capone, provided technical support, and the Lake George Camping Equipment Company marina in Bolton Landing serviced the survey team's workboat.

On June 26, 2004, Bob Benway and Joseph W. Zarzynski made a dive to examine the shipwreck. The team discovered an outboard racer that sits upright on a soft sediment lake bottom. The research group measured the vessel at eleven feet, four inches long by four feet, eight inches wide. The divers also did an inventory of the hardware on the watercraft, photographed it and sketched the shipwreck.

The boat is painted blue and white, with its blue registration numbers still present. The starter key appears to still be in the ignition. There are two metal fuel tanks, one inside the vessel and the other lying just outside on the starboard side. The two-spoked steering wheel, painted blue, has an orange and white "starburst" pattern on its hub. In the stern, there appears to be a battery inside the speedboat. A reddish-orange seat with back support is still attached to the forward most of two wooden thwarts, but the seat frame appears broken. Three metal cleats, two aft and one

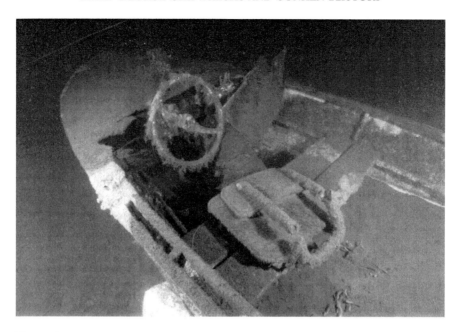

This underwater photograph shows a small outboard engine-powered racing boat that was discovered in Lake George in 2004. *Courtesy of Bob Benway/Bateaux Below.*

on the forward deck, are found on the hull structure. A bow light, heavily encrusted, is located forward of the damaged windshield. There is also a speedometer on the dashboard.

The vessel's outboard is painted blue, though it may at one time have been painted an orange-like color. The racing boat's outboard engine was identified as being manufactured by the Scott-Atwater Outboard Company, possibly with the Bail-a-Matic option that allowed for mechanical drainage of water in the stern, using suction generated from the outboard. The firm started making outboard engines in the mid-1930s, and by the early 1940s, it had become the second-largest outboard manufacturer in the country.

There is no noticeable major structural damage to the outboard racing boat. From its appearance, it is hypothesized the watercraft sank four or five decades ago. Like the great gunfighters of the Wild West who lived and died by their blazing six-shooters, it is most likely this little racer probably went out in a hail of speed, as its outboard engine blasted the boat along until it hit a rogue wave and sank. Today the blue and white outboard racing craft sits in the Lake George abyss, a ghost from the not-too-distant past, when the roar and shriek of the outboard engine ruled the waves.

Steamboat *Pamelaine I* Wreck Parts Found

Published September 3, 2004, Lake George Mirror

On May 14, 2004, during a side scan sonar survey at Lake George, Bateaux Below discovered a shipwreck-like target lying on the bottomlands of the lake. The Klein side scan sonar target was one of several possible shipwrecks discovered during a four-day remote sensing project. Following numerous scuba dives to ground truth other higher-priority sonar targets, on July 30, 2004, two Bateaux Below members made a reconnaissance dive to the mysterious target. To their surprise, the target was actually part of a vessel, the canopy top of the *Pamelaine*, a twenty-eight-foot-long, twentieth-century steamboat that overturned in a storm nearly three decades ago.

The three-person archaeology team that found the wreckage was comprised of Bob Benway, Vincent J. Capone and Joseph W. Zarzynski. For the past several years, Bateaux Below has been searching the waters of Lake George conducting an inventory of the waterway's submerged cultural resources. The 2004 project is supported by a $3,000 grant from the Fund for Lake George, Inc.

Following the May 14, 2004 sonar discovery of the deepwater shipwreck-like target, Capone, the team's remote sensing technician, analyzed the sonar record and hypothesized that the target had "approximately one foot of vertical relief." Capone's analysis was correct. Following the inspection dive, Benway described the light-colored canopy as barely sticking up from the lake bottom. At first glance, Benway thought it might be an overturned jon boat with squared ends.

The canopy lies upside down, and even after twenty-nine years underwater, it is intact. The canopy measures approximately twenty feet long by five feet, nine inches wide. About one-third the way aft is a circular hole cut into the canopy that received the vessel's smokestack. A light-colored bow adornment, which appears to be an eagle-like bird, is still attached to the forward end of the canopy. The steamboat's red navigation reflector board lies on the lake bottom near the canopy. Three portable artifacts, vintage-type lights, rest on top of the canopy. What appears to be the canopy's awning is still rolled up and is attached to the canopy structure. The steamboat's two name boards lie face down on the lake bottom, probably having fallen off the canopy after the fasteners that held them to the vessel wasted away. One of the name boards was turned over by the dive team, photographed for identification

and then replaced in its original location. The archaeology team disturbed nothing else at the site.

According to William Preston Gates's book, *Lake George Boats and Steamboats*, the *Pamelaine* was a steamboat owned by Bolton Landing resident Dr. George Mason Saunders. The vessel had a twenty-eight-foot-long, 1918 Fay & Bowen hull that Saunders purchased from Lamb Brothers in 1968 and then converted into a steamboat, adding a modern-era canopy. Saunders, a dentist from Albany, New York, named the *Pamelaine* after his two daughters, Pam and Elaine.

Gates's book reported that the *Pamelaine* overturned "in a strong wind storm," and the watercraft's "equipment sank to the bottom." However, the steamboat's hull survived. Saunders told Zarzynski in a telephone interview that the boating mishap "occurred in July 1975."

Saunders once wrote about the incident, his account published in *Beckmann Boatshop Limited*: "I started with a narrow hull that was over-powered; a metal canopy and supports made the boat rather tender. During a severe storm the boat capsized and left us swimming."

In the early 1980s, Saunders sold the vessel and later put another steamboat on the lake, the twenty-two-foot-long *Pamelaine II*.

In early August 2004, Zarzynski met with Alan Bauder, the Submerged Lands and Natural Resources manager of the New York State Office of General Services (OGS). The OGS is responsible for the custodial care of Lake George's bottomlands. Bauder was informed of the find, and he suggested that since the canopy and associated artifacts were less than fifty years old and, thus, not "historic" that the steamboat parts were property of the owner, "Doc" Saunders. In mid-August 2004, the OGS ruled that the "State has no ownership interest in the debris from the vessel." Thus, on August 24, 2004, Bateaux Below notified Saunders of its discovery. The underwater archaeology team will provide Saunders with photographs of the *Pamelaine I* canopy site and volunteered to recover the transportable artifacts for the steamboat pilot.

Divers Present Saunders with Steamboat Relics

Published May 2005, Lake George Mirror

Three decades ago, during the summer of 1975, Bolton Landing resident Dr. George Mason Saunders, an Albany dentist, was treading water in Lake George just after his twenty-eight-foot-long steamboat, the SS *Pamelaine*,

capsized and nearly sank off Bolton Landing. Fortunately, Saunders and his single passenger were not injured. Surprisingly, the vessel's hull floated, vertical in the water, with about one foot of the bow above the waterline. Saunders later related that several life jackets stowed under the foredeck provided extra flotation and kept the hull from sinking. Saunders said Lamb Brothers marina towed his barely floating boat back to shore, and it was hauled out of the lake. However, the watercraft's metal canopy, boiler and other hardware sank. At that time, Saunders doubted he would ever again see any of those artifacts.

On August 24, 2004, Bateaux Below's Joseph W. Zarzynski telephoned Saunders and left a message on his phone recorder, informing him that the underwater archaeology team had located the canopy from the *Pamelaine*.

"It was like a call from Mars," said Saunders. "It was too good to be true."

The research team had discovered the steamboat canopy on May 14, 2004, during a Klein 3000 side scan sonar survey while searching for shipwrecks and other submerged cultural resources. The remote sensing survey, directed by Vincent J. Capone, and follow-up reconnaissance dives were supported by a $3,000 grant from the Fund for Lake George, Inc. For several weeks after the sonar fieldwork, Bateaux Below conducted scuba dives to inspect targets from the survey. Following an inspection dive to the site that identified the sonar target as the steamboat *Pamelaine*'s canopy, the underwater archaeology group contacted the State of New York. In mid-August 2004, the Office of General Services ruled that since the canopy and artifacts were not "historic" and were less than fifty years old, the state had "no ownership interest in the debris from the vessel." Encouraged by this decision, Bateaux Below contacted Saunders, and the team volunteered to retrieve several artifacts for the steamboat pilot. Prior to the recovery, the group contacted East Carolina University's Dr. Bradley Rodgers, a conservator with the institution's underwater archaeology program. Rodgers advised how to treat the pieces prior to being returned to Saunders.

So, on November 17, 2004, with boat traffic minimal and a good weather day, Bob Benway and Zarzynski donned their scuba gear and plunged down to the site. Three artifacts were retrieved: one of the vessel's wooden name boards, a wooden eagle that was the bow adornment and a lantern that, years earlier, had been a gift to Saunders. The artifacts then underwent several weeks of basic conservation treatment.

"Conservation was minimal since the artifacts were from freshwater and had not been in the lake for a century or two," said Zarzynski.

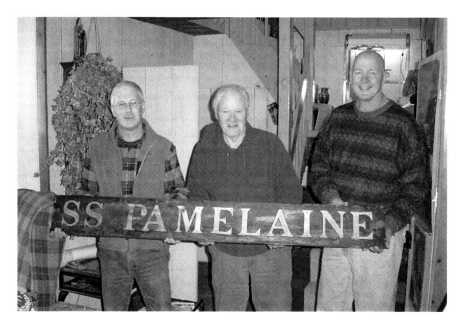

Bob Benway (left), "Doc" Saunders (center) and Joseph W. Zarzynski (right) with a name board from the SS *Pamelaine*. Bateaux Below found the sunken vessel's canopy and then got permission from the State of New York to retrieve and return this to its owner, Dr. George Mason Saunders. *Courtesy of Peter Pepe.*

On January 29, 2005, with Lake George frozen and the temperature outside well below freezing, Saunders saw his artifacts for the first time in nearly thirty years. A contingent from Bateaux Below and Peter Pepe of Pepe Productions, a multi-media corporation based in Glens Falls, visited Saunders at his Bolton Landing residence. Pepe shot video and also photographed the event to record the maritime history of Lake George.

When Saunders was presented with the wooden eagle artifact, still intact and well preserved, he smiled at the inanimate object and declared, "Welcome home, buddy."

Saunders related how the capsizing of the *Pamelaine* created a major problem for his summer plans in 1975. The annual Environmental Boat Race was only a few weeks away, and Saunders was without a working steamboat.

"I had won the previous two years, and if I captured the third consecutive race, I would be able to keep the trophy," commented Saunders. "So, I dashed off to Maine, got a new steam boiler and worked day and night to ready the *Pamelaine* for the race."

Saunders's efforts paid off, too, as the *Pamelaine* beat a steamboat piloted by Paul Eckoff of Long Island, a summer resident of Lake George. The *Pamelaine I* was eventually retired, and a new steamboat, the *Pamelaine II*, was put onto the lake.

"Thirty years ago, as I watched the white canopy of my steamboat sink deeper into the lake, I kissed everything off," reflected Saunders. "But as they say, the lake sometimes gives back what it takes."

For years "Doc" Saunders has likewise given back, providing numerous courtesy rides on his steamboat so that friends and strangers alike could relive a bygone era when steamboats were king on the Queen of American Lakes.

Steamboat Whistle Recovered from *Pamelaine* Canopy Wreck

Published January 2006, Lake George Mirror

Cinema aficionados recall the 1951 classic *The African Queen*, a tale of two mismatched companions on a small steamboat in east Africa during World War I. In the movie, Charlie Allnut (Humphrey Bogart) and Rose Sayer (Katharine Hepburn) quarrel frequently, as Allnut guides his supply steamer along a river to deliver cargo to distant villages. To announce his vessel's arrival, Allnut blasts the boat's steam whistle.

Like the movie character portrayed by Bogart, for years Bolton's Dr. George Mason Saunders sounded the steam whistles in his watercraft, the SS *Pamelaine*, as it glided along the waters of Lake George. In 1975, during a boating trip on the lake, the *Pamelaine* capsized in unsettled waters. The steamboat's canopy separated from the hull and sank. Fortunately, "Doc" Saunders and the single passenger aboard the vessel survived, as did the hull, which floated. The hull was salvaged, but the canopy was lost and was nearly forgotten. Saunders eventually put a second steamboat on the lake, also calling it *Pamelaine*.

In 2004, during a Klein 3000 side scan sonar survey, Bateaux Below discovered the *Pamelaine*'s canopy lying in deep water off Bolton Landing. Following the find, the New York State Office of General Services ruled that the canopy was not "historic" because it was less than fifty years old and thus the state had no custodial ownership of it. Therefore, at the request of Saunders, in November 2004, Bateaux Below divers retrieved several

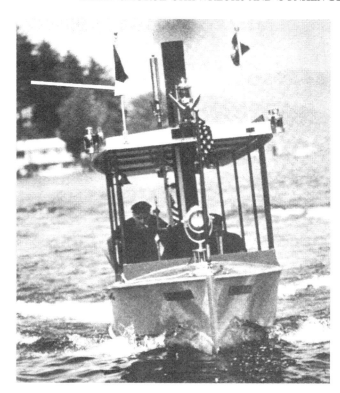

This photograph shows "Doc" Saunders piloting the *Pamelaine I* during a boat race. The arrow shows the brass whistle that was recovered for Saunders years after the steam vessel capsized and the boat's canopy hardware was lost. *Courtesy of the Adirondack Chapter—Antique & Classic Boat Society.*

artifacts from the canopy. After preliminary conservation, in January 2005, the artifacts were presented to Saunders. Pepe Productions videotaped and photographed the return of artifacts to Saunders. At that time, Saunders asked if one of the vessel's steam whistles could be retrieved.

So, on October 15, 2005, Bill Appling, Bob Benway and Joseph W. Zarzynski dived the deepwater site and recovered a two-foot-long, fourteen-pound brass whistle. Following preliminary conservation, the whistle will be returned to the Saunders family. Brass, an alloy of copper and zinc, also contains trace elements of arsenic, antimony and phosphorus that contribute to minimizing corrosion, thus allowing for easy restoration of the brass's luster.

The invention of the steam whistle is somewhat cloudy. However, it may have been invented in Britain in 1833 following a train collision. The steam whistle thus became an important warning call to announce the approach of trains and steamboats.

When informed of the recovery of his whistle, Saunders, who has been undergoing medical treatment for health concerns, was obviously buoyed

by the news. Saunders's enthusiasm can be described by Bob Dylan's lyrics from "Dear Landlord": "When the steamboat whistle blows, I'm gonna give you all I got to give."

Cold Case: 1926 Mystery of Two Missing Hunters (Part One)

Published July 29, 2005, Lake George Mirror

On November 21, 1926, the *New York Times* reported that two hunters and their "improvised motor boat" had vanished at Lake George. Authorities believed the men had drowned, possibly after their watercraft ran onto shoals in a storm. John J. Eden and L.D. Greene, two prominent Middletown, New York citizens, were missing, and their disappearance sparked off one of the most intensive manhunts ever undertaken at the lake. Now, eight decades later, some questions about this "cold case" have been answered thanks to recent sleuthing through old newspaper clippings and after an underwater archaeological survey at the bottom of Lake George.

What made this case so newsworthy was that Eden was the superintendent of E. Roland Harriman's Arden, New York estate. Harriman was one of America's great financiers and philanthropists. Harriman was a graduate of Yale University and was a classmate and close friend of Prescott Bush, father of President George H.W. Bush and grandfather of George W. Bush, the forty-third president of the United States. Harriman and Prescott Bush became partners in Brown Brothers Harriman, a major banking services firm. During the 1926 search for the missing outdoorsmen, Harriman journeyed to Lake George, chartered an aircraft to aid in the search and offered a $500 reward for the recovery of either man.

Greene, an agricultural agent for the New York, Ontario & Western Railroad, and Eden came to the Charles Buck cottage on the east side of Lake George to hunt and visit some of the islands on the waterway, especially those in the Narrows. Newspaper articles reported that the two men had used a small steel rowboat, borrowed from Glens Falls resident Norman Davis, to go duck hunting. Law enforcement officials believed Eden and Greene may have camped out on one of the islands of the lake on November 15, and the following day, the two men went to a Bolton Landing store to buy food before returning to Buck cottage.

The effort to find these two men did uncover evidence that the two sportsmen may have drowned, not in the Narrows, but a few miles farther south. Several pieces of flotsam were found. Eden's hat was reportedly recovered floating in Basin Bay, and nearby, a rear seat cover off a rowboat was discovered. Searchers also retrieved a roll of film and a chocolate bar wrapper. A Bolton storekeeper later identified the candy wrapper as having been purchased by Greene at his shop on November 16, 1926. Two boat oars were also recovered near Plum Point. Based on those discoveries, state troopers grappled for the bodies near Basin Bay and Cotton Point.

Early into their Lake George hunting trip, Greene wrote to his wife. Part of Greene's letter was released to the media: "Have borrowed a steel boat. The kicker goes on it fine and yesterday we toured all this end of the lake, down the lake below the islands which we can see from here [Buck cottage]."

Addison Peers, a Bolton farmer, said he heard a small motorboat between Cotton Point and Guernsey Point about 4:30 p.m. on November 16, and then the noise suddenly stopped. The weather on November 16 was described as a storm and probably was a key factor in their disappearance.

The *Glens Falls Times and Messenger* newspaper reported on December 1, 1926, that an oar was found south of Cotton Point near where Eden's hat had been found. However, two weeks of intensive searching by up to one hundred state troopers, sheriff deputies, American Legion members and other volunteers failed to find either of the lost men.

Finally, in early July 1927, Greene's body surfaced, discovered by Captain Frank W. Hamilton of the excursion boat *Scioto*. Three weeks later, Arthur Burton, a Lake George boatman, found Eden's body after it floated to the surface.

However, soon after Eden and Greene were recovered, this story became a cold case, nearly forgotten. Then, nearly eight decades later, an underwater archaeologist unearthed contemporary news stories of this boating mishap. Following leads in the archives and also at the bottom of Lake George, the cold case of Lake George's two missing hunters is closer to being solved.

Authors' note: The next chapter, the last in the two-part series, examines how inquisitive underwater archaeologists may have cracked the case of the two missing hunters.

Cold Case: 1926 Mystery of Two Missing Hunters (Part Two)

Published August 5, 2005, Lake George Mirror

In early 2004, underwater archaeologist Joseph W. Zarzynski was searching through old issues of the *New York Times* when he found several articles about the disappearance of two hunters, John J. Eden and L.D. Greene. The two Middleton, New York men had drowned in Lake George in November 1926 while boating during a hunting trip. In late 2004, this story became special because one contemporary local newspaper article recorded that the two sportsmen were in "a fourteen-foot steel boat with an outboard motor."

That reference reminded Zarzynski of one of Bateaux Below's shipwreck finds a decade ago. Thus, the underwater archaeology team developed a hypothesis that a small wreck discovered in 1995 was actually the watercraft that Eden and Greene had been on board when the pair mysteriously disappeared and drowned.

The wreck was found on May 12, 1995, during a Klein side scan sonar survey to find and inventory shipwrecks in the South Basin of Lake George. The 1995 remote sensing survey, with Vincent J. Capone as sonar technician, was supported by a $2,000 grant from the Preservation League of New York State. It resulted in the discovery of several previously unknown wrecks.

On June 6, 1995, Bob Benway, Scott Padeni and Zarzynski made a dive to ground truth one of the wreck-like sonar targets discovered during recent side scan sonar fieldwork. Though visibility was low due to silt kicked up from the scuba search, the divers nevertheless found the target—a small shipwreck—and measured it at fourteen feet long. They noted the watercraft carried a small vintage outboard engine. During a second dive a week later, underwater video was shot, and the shipwreck was left undisturbed. At that time, no specific reason for the boat's sinking was determined, but it appeared as if the vessel had not been deliberately sunk.

Zarzynski's 2004 research discovery, however, prompted a reexamination of the shipwreck. The decade-old eight-millimeter videotape was transferred to digital format, courtesy of Pepe Productions, a local multi-media company. The nine-year-old underwater video revealed much to the research team.

Several pieces of information point to this vessel being the lost 1926 boat. First, the boat lies south of Canoe Island not far from where Eden and Greene were found in July 1927. The *Lake George Mirror* reported that

Greene was located floating "between Ripley's Point and Cleverdale." The news article reported that "it is believed…[Greene] rose Saturday night" but was not found until Sunday morning. Greene's body probably drifted north overnight due to a typical summertime south breeze.

Greene's hat was still on his head, and he carried a hunting and fishing license and a chauffeur's license. The licenses helped the deputy sheriff's commission identify the body. Also found were other personal items, including a "kodak" (camera), a jackknife and $19.10.

Oddly, Greene's pants were "cut up each side as far as the knees." Were they tears from the motor's prop, knife cuts from a desperate man who tried to remove water-filled boots that weighted him down or pants ripped by Eden as he clawed to save Greene from drowning?

Three weeks after Greene was found, Arthur Burton, a Lake George boatman, discovered Eden floating south of Long Island. Burton hooked Eden's clothes and towed the body to the Antlers Hotel dock on the lake's west side.

The sportsmen's vessel was described as "a fourteen-foot steel boat with an outboard motor." Only three steel boat wrecks have been found by Bateaux Below in the area of the South Basin, near where the two bodies were recovered. One of those is a steel-hulled vessel that is eighteen feet long and without an outboard engine. A second vessel, measuring thirteen feet, ten inches, was made by the Michigan Steel Boat Company. However, it also does not have an outboard motor. Thus, the vessel found by Bateaux Below in 1995 is the best candidate for the missing 1926 boat. It was measured at fourteen feet long, has a metal hull and carries a vintage outboard motor.

The discovery of personal and boat articles during the 1926 search likewise supports the hypothesis that the Eden/Greene boat has been found. Eden's hat, a candy wrapper, a roll of film, an oar and a boat seat cover were all found near Basin Bay and Cotton Point, only a few miles from the shipwreck. Furthermore, the wreck's location is midway between the site where the flotsam was found, and the boat motor was apparently last heard by a lakeside resident at Buck cottage on the lake's east side.

Therefore, it appears the 1926 missing hunters' boat has been found. Why this watercraft sank awaits further underwater forensic investigation. However, Lake George does not easily give up all its secrets.

1926-1927
Missing Hunters Chronology and Map

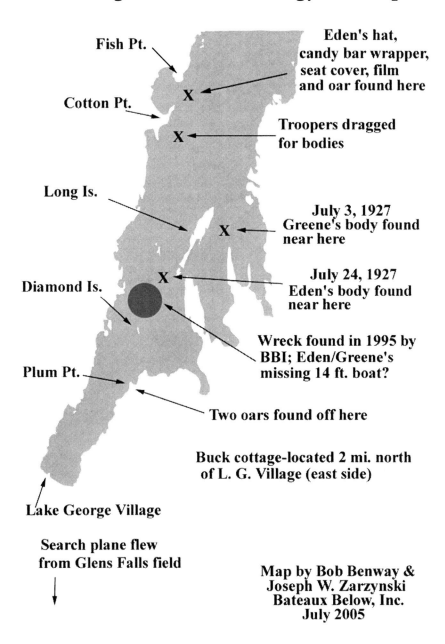

Map of events associated with the 1926 mystery of two missing hunters. *Courtesy of Bob Benway and Joseph W. Zarzynski/Bateaux Below.*

DIVE COMMEMORATES FORTY-FIFTH ANNIVERSARY OF SINKING OF LAKE GEORGE'S MYSTERY SUB

Published August 19, 2005, Lake George Mirror

To mark the forty-fifth anniversary of the disappearance and sinking of a fifteen-foot-long submarine in Lake George, on August 4, 2005, underwater archaeologists with Bateaux Below made a scuba dive to visit the yellow submarine, photograph it and examine its structural integrity. The underwater vehicle, named *Baby Whale*, disappeared from its dock at Lake George over the evening of August 4, 1960, reportedly a victim of pranksters. After an extensive boat, air and scuba search, the homemade sub was nearly forgotten until discovered on June 18, 1995, by Bateaux Below's Bob Benway and Joseph W. Zarzynski during a submerged cultural resources survey dive.

Area residents James Parrott, Gerald Root and Art Jones built the sub for the purpose of photographing Lake George's sunken French and Indian War bateau wrecks. In 1758, British and provincial troops deliberately sank 260

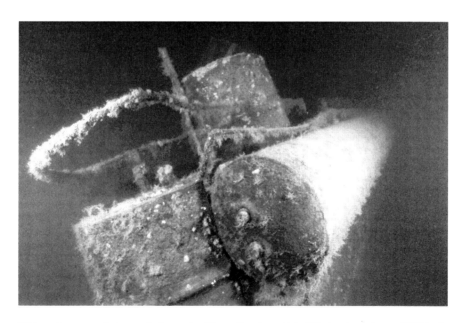

This underwater photograph shows the fifteen-foot-long *Baby Whale* submarine, a 1960-built research sub that was stolen from its dock in 1960 and then sunk. It was discovered in 1995. *Courtesy of Bob Benway/Bateaux Below.*

bateaux and several other types of warships to protect the vessels over the winter from raids by their enemies, the French and their Native American allies. The British retrieved some sunken watercraft in 1759, but many were never recovered.

The Lake George sub had a single twelve-inch-diameter glass porthole on its starboard side for navigation aid and photographic purposes. According to contemporary newspaper accounts, the sub was made of aluminum, iron and cement. It reportedly weighed 3,700 pounds. The underwater vessel was built to accommodate two people, and it was equipped with a conning tower, exterior ballast tanks and rails. When the vessel disappeared in 1960, it was not quite ready for submerging into the depths of the lake since some gear had not yet been installed.

The submarine was constructed during a time when underwater exploration was intriguing to the scientific community, as well as the general public. In 1960, two teenage sport divers at Lake George discovered several sunken bateaux deliberately sunk in the lake by British forces in 1758. Furthermore, in January 1960, the *Trieste* bathyscaphe set a deep dive record to 35,813 feet in the Marianas Trench, Pacific Ocean. Thus, the *Baby Whale* was to a large degree a product of those events.

Following the submarine's 1995 discovery, Bateaux Below notified state authorities of the find. In 2010, the underwater craft will be fifty years old. Thus, it will then be considered historic, one of the criteria to be nominated to the National Register. It is hoped that the pioneering research submarine can be nominated to the National Register of Historic Places in 2010 or thereafter. Federal, state and local preservation laws protect the sunken submarine. In 1995, six weeks after the discovery of the *Baby Whale*, Bateaux Below divers erected signage next to the sunken research vessel. The state approved the signage text that informs divers that the submarine is protected from vandalism.

The recent August 4, 2005 dive to Lake George's yellow submarine revealed the underwater vehicle remains in good structural condition though heavily rusted. The *Baby Whale* was never deployed in 1960 to photograph sunken colonial bateau wrecks. Nevertheless, it was an early attempt at Lake George to use emerging state-of-the-art exploratory equipment to decipher the waterway's secrets of the deep. Therefore, the yellow submarine is an important chapter in the story of Lake George's Sunken Fleet of 1758.

Hague Mystery Wreck

Published September 9, 2005, Lake George Mirror

Scattered around Lake George's bottomlands are shipwrecks, submerged time capsules that give insight into the past. Some sunken boats in Lake George are characterized by their wooden hull construction and their inboard motors. Companies like Albany Boat Corporation, Chris-Craft, Fay & Bowen, Gar Wood and Hacker Craft built these boats. Commonly called runabouts, many had hull designs that allowed them to plane on top of the water rather than plow through it. One of Bateaux Below's recent discoveries is a runabout wreck with an enigmatic past.

On June 4–5, 2005, Bateaux Below conducted a Klein 3000 side scan sonar survey with Vincent J. Capone as sonar operator, part of a multi-year project to inventory all the lake's shipwrecks and other submerged cultural resources. That endeavor was financed in part by a $3,000 grant from the Fund for Lake George, Inc. Two corporate donations—$1,000 from AngioDynamics and $350 from the Adirondack Trust Company—also helped to offset rising fuel costs for the research boat and other expenses.

Since 1988, Bateaux Below members have conducted searches to locate and collect baseline data on shipwrecks and other submerged cultural resources in Lake George. Nearly 60 percent of the thirty-two-mile-long waterway has been surveyed, and 179 submerged cultural resource sites are in the Bateaux Below inventory, which totals 207 individual resources; some sites have multiple shipwrecks. Nineteen of these are runabout wrecks.

The early runabouts were sometimes victims of mechanical accidents. They occasionally caught fire, burned to the waterline and sank. This generally happened when gas fumes leaked into the bilge, and the fumes were ignited by a short circuit or backfire of the engine.

One of the June 4, 2005 sonar targets from Hague waters appeared to be a wooden runabout wreck. On August 2, 2004, Bob Benway and Joseph W. Zarzynski, with topside support from Jane and Dr. Russell P. Bellico, dived the sonar target. The scuba inspection revealed a thirty-foot-long wooden wreck that has been tentatively identified as a Fay & Bowen runabout. It apparently caught fire, and flames quickly spread forward and aft. When the boat's upper structure burned to the waterline, the runabout lost its buoyancy and sank. All that is left of the sunken boat is its lower hull, the stem and twisted metal cutwater at the bow, the engine hardware and part

Twentieth-Century Shipwrecks

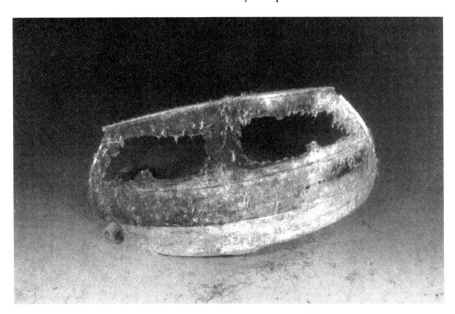

This underwater photograph shows the stern of a burned thirty-foot-long long shipwreck lying off Hague. The wooden runabout caught fire and sank in 1966. Bateaux Below discovered the wreck during a side scan sonar survey in 2005. *Courtesy of Bob Benway/Bateaux Below.*

of the transom. The fire may have started on the port side, since that was destroyed more than the starboard.

There were some surprises noted by the dive team. Several masonry blocks lay in the forward section of the vessel and possibly served as trim. Not far off the wreck lay what is probably the runabout's fuel tank. Furthermore, near the bow of the shipwreck was part of a water intake pipe from a lakeside cottage that appeared to have been deposited there after being dragged away by ice or from an errant boat anchor. The out-of-place piping was surprising since it lay fairly far out from shore.

To date, no archival evidence has been found to fill in the history of this watercraft. However, Dr. Russell P. Bellico, a historian, does have oral history that is a probable match for the newly discovered shipwreck.

On July 25, 1990, Bellico interviewed Ticonderoga's Gordon Burleigh, a former official of the Lake George Park Commission. Burleigh, now deceased, said a Fay & Bowen launch, "twenty-five feet long…owned by Oliver & Margaret Smith, caught fire and sank" in the late 1950s near where the wreck was discovered.

Recently uncovered oral history likewise supports the hypothesis that this sunken runabout is the Smith vessel! Further literature research may tell us more about the Hague mystery wreck. Until then, this shipwreck will simply be referred to by its inventory designation, BBI-176.

Authors' note: Further archival research uncovered a Glens Falls Times *newspaper article dated May 31, 1966. The news story identified the vessel as that of Mr. and Mrs. Oliver Smith. However, the mishap happened in 1966, not the "late 1950s," as initially indicated in oral lore.*

Has Racing Royalty's Boat Been Found in the Lake?

Published June 30, 2006, Lake George Mirror

He was handsome and rich and was an international sportsman. Count Casimir S. Mankowski, a summertime resident of Bolton Landing during part of the first two decades of the twentieth century, stunned the sporting world when he won the 1913 Gold Cup speedboat race at Alexandria Bay, New York, in his vessel, *Ankle Deep*. Count Mankowski was reportedly the son of a wealthy millionaire mother married to a Polish nobleman. Archival research, combined with archaeological evidence, suggests that a twenty-five-foot-long race boat sunk in Lake George and discovered four years ago is probably the *Gem*, one of Mankowski's vessels.

On May 17, 2002, Bateaux Below's Vincent J. Capone, John Farrell and Joseph W. Zarzynski discovered the shipwreck during a Klein 2000 side scan sonar survey. That effort was part of an ongoing submerged cultural resources inventory of Lake George initiated in 1988. With a little over half the lake surveyed, the multi-year project has resulted in over two hundred shipwrecks and other submerged cultural resources being recorded on the inventory.

The 2002 shipwreck project survey consisted of twenty-two days of fieldwork: five days of side scan sonar surveying, one day using ground-penetrating radar deployed in shallow water and sixteen days scuba diving and boat work. The 2002 work was supported by a $5,000 grant from the Fund for Lake George, Inc., with donated services from Bateaux Below. The fieldwork resulted in the discovery of twelve previously unrecorded shipwrecks.

Twentieth-Century Shipwrecks

One of those wrecks, designated BBI-131, is a sleek wooden vessel lying upright on the lake bottom. In June 2002, Bateaux Below divers conducted a non-invasive preliminary survey of the sunken vessel. The archaeology team acquired eight-millimeter video footage and collected basic measurements of the wreck.

The launch-shaped watercraft measures 25 feet long and 3.5 feet wide amidships. The team noted that the shipwreck was an early twentieth-century racing boat. The vessel's engine, rudder, most of its hardware and its deck were removed prior to its deliberate sinking. Several large rocks found inside the shipwreck indicate it had been abandoned.

The lightly constructed and fragile boat lists slightly to port, and even after nine decades of algae growth over the hull, its white paint is still visible. No name, however, is noticeable on the boat's bow or transom. Wooden coaming, a raised rim around the passenger compartment to keep water out, has separated from the starboard gunnel. Some other structure around the bow has likewise pulled away from the hull. Several disarticulated boards lie inside in the amidships area. Approximately 65 to 70 percent of the hull remains.

Archival research strongly hints that this shipwreck is one of several boats owned by Mankowski and is probably the *Gem*. Other Mankowski vessels once on Lake George included the thirty-two-foot *Ankle Deep*, the twenty-six-foot *Ankle Deep Too*, the thirty-five-foot *Hummer* and the *Scat*, length not recorded.

Local and national newspapers reported that on August 31, 1909, Mankowski piloted the *Gem* to victory in the Worden Cup at Lake George, a race sponsored by the Glens Falls Club. The contest, for vessels twenty-five feet long and under, was six miles long, with two laps over a three-mile triangular course.

Four years later, Mankowski won one of the world's greatest speedboat races, the Gold Cup, aboard *Ankle Deep*. The following year, 1914, he defended the Gold Cup at Lake George but lost. The Gold Cup is still run, this year (2006) on the Detroit River, and is considered to be the Indy 500 for speedboats.

Casimir Mankowski lived for several summers in Bolton Landing with his lovely wife, Lena. Before coming to Lake George, Count Mankowski raced motorcycles in events around the northeast. Mankowski died of typhoid on April 23, 1917, while spending the winter in New Orleans, Louisiana. He was only thirty-eight years old.

Bateaux Below has no current plans for an in-depth archaeological study of the shipwreck.

Studying the "Wreck" in a Lake George Shipwreck

Published July 28, 2006, Lake George Mirror

Over the past three decades, underwater archaeologists have become increasingly eager to understand the processes by which a shipwreck is formed. Most shipwrecks are often a long way from the Hollywood image of a submerged vessel as a time capsule. Simply put, there is a significant difference between a floating boat and that same watercraft as a shipwreck. When a vessel is sunk, the submerged site suffers changes of state until the watercraft reaches equilibrium with its aquatic environment. The range of changes from vessel to varying stages of shipwreck is known as "wreck formation processes." Recently Bateaux Below members revisited a Lake George shipwreck it mapped eighteen years ago in 1988 to better understand the "wreck" in a sunken vessel.

In 1988, individuals of the group that became known as Bateaux Below conducted a non-invasive archaeological mapping of an early twentieth-century launch known as the "forty-foot-long steel hulled shipwreck." The shallow-water shipwreck, designated BBI-17, is a metal launch with an intact hull sitting upright on the lake bottom. The vessel's engine, decking and rudder were removed before it was deliberately sunk. The 1988 study provided baseline data that now gives underwater archaeologists a unique opportunity to learn more about wreck formation processes at the Queen of American Lakes.

In July 2006, Bateaux Below divers returned to this wreck, whose name and history are unknown. Prior to the visit, the team reviewed eighteen-year-old archaeological drawings and side scan sonar documentation of the site. The objective of the reconnaissance was to examine how the shipwreck may have changed over the years. The team compared present structural conditions to the vessel's physical integrity recorded in 1988. Of particular interest to Bateaux Below was to observe what happens over time to a shallow freshwater shipwreck constructed mostly of metal. The July 2006 site investigation was revealing.

The entire port side of the metal vessel has fallen inboard. This is the side that is directly exposed to the flow of the lake's northerly current. The collapse of the port side is most likely due to fatigue of the metal frames that hold up that part of the hull. The initial collapse of the port side

Twentieth-Century Shipwrecks

"Steel Hulled Wreck" 1988 Drawing
Annotations from July 2006 Observations

- Gunnel bent inboard
- Crosspiece collapsed
- Vessel beginning to list to starboard
- Crosspiece collapsed
- Port side fallen inboard
- First area to fail

Drawing-John Farrell, Annotations-Bob Benway (BBI)

This annotated drawing shows changes in a Lake George shipwreck as it has deteriorated, part of its "wreck formation processes." *Courtesy of John Farrell & Bob Benway/Bateaux Below.*

probably began in the aft area. In 1988, a large hole was observed here, possibly inflicted during the sinking and abandonment process. Without intact frames to support the port side at this location, the weight of the gunnel and the small aft deck pulled this side inward. After this side fell into the hull, the starboard side began to tumble outboard. Two wooden crosspieces, one in the stern and the other forward, have also collapsed into the hull. Just aft of the bow, the gunnel has twisted from the weight of the starboard side.

Eventually, the starboard hull will collapse outward, as the shipwreck reaches equilibrium with its environment. The archaeology team was surprised at the degradation of this sunken vessel. Factors like seasonal water temperature changes at a shallow site, a slight lake current and even a freshwater environment do have a profound effect on a metal boat sunk in Lake George. Had the vessel been sunk in deep water, where the oxygen level is diminished, corrosion of the metal wreck would have been less.

Shipwrecks are subjected to continual environmental processes that shape the appearance of the site even in a low activity zone. Studying wreck formation processes at Lake George helps gain greater insight into the nuances of the archaeological record.

Bateaux Below Proposes *Forward* Shipwreck for National Register

Published August 10, 2007, Lake George Mirror

Bateaux Below, Inc., a not-for-profit corporation that studies Lake George shipwrecks, has proposed that the *Forward* shipwreck be considered for nomination to the National Register of Historic Places. On July 29, 2007, the underwater archaeology team contacted the New York State Historic Preservation Office, asking that the Lake George shipwreck be considered for nomination to the National Register. Bateaux Below was then asked to prepare an outline summarizing the vessel's significance to determine if there "is a convincing argument that can be tested before doing a full nomination."

Since then, Bateaux Below divers have inspected the shipwreck and have also sent to the state the required proposal on the *Forward*'s historical significance and its current structural status. If the outline is approved, Bateaux Below will prepare a formal nomination to get the shipwreck listed on the National Register of Historic Places. This process generally takes a year or more before it is listed.

The *Forward* was a forty-five-foot-long by six-foot, eight-inch-wide wooden gasoline-powered launch that was purchased in 1906 by industrialist William

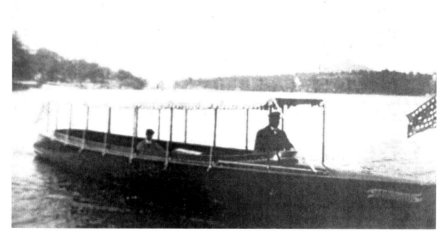

This early photograph is of the 1906-built *Forward*, one of the first gasoline-powered vessels on Lake George. The forty-five-foot-long launch is now part of a shipwreck park for divers. *Courtesy of Ted Caldwell & Bixby Family.*

K. Bixby of St. Louis, Missouri, and Bolton Landing. William K. Bixby's son, Harold, was a financial supporter of Charles Lindbergh's 1927 transatlantic flight, and Harold Bixby also reportedly named Lindbergh's plane, the *Spirit of St. Louis*.

The June 16, 1906 issue of the *Lake George Mirror* newspaper reported that the twin-screw launch was powered by two thirty-horsepower gasoline engines. It could carry thirty people "comfortably" and was finished with a "natural wood exterior" and a "mahogany dressed deck." The luxury watercraft had an open cockpit with the pilot well forward of the passengers, a waterborne version of today's stretch limo. The *Forward* could reach a speed of twenty-two miles per hour.

On June 4, 1989, Bateaux Below divers first located the wreck. The team was able to identify the shipwreck from surviving letters of its name still visible on each side of the bow. From 1989 to 1992, Bateaux Below mapped the shipwreck that lies in 37 to 42 feet of water about 1,500 feet east of Diamond Island.

In 1993, the site opened as one of the lake's first two shipwreck preserves for scuba divers. Called "The *Forward*," it is part of Lake George's Submerged Heritage Preserves. Along with Lake George's "The Sunken Fleet of 1758" preserve, this site has the distinction of being the first shipwreck park for divers in the state.

Over 1997–1998, a $2,420 grant from the Fund for Lake George, Inc., provided monies to remodel "The *Forward*," and in 1998, it reopened as "The *Forward* Underwater Classroom." A hallmark of the park is its series of underwater stations that inform visiting divers about water temperature patterns, fish life, vegetation, geology, color loss at depth and underwater archaeology.

FORWARD SHIPWRECK PASSES STATE REGISTER OF HISTORIC PLACES

Published September 26, 2008, Lake George Mirror

On September 17, 2008, Lake George's *Forward* shipwreck passed the New York state board's review toward listing on the State Register of Historic Places. That is a major hurdle in getting the early twentieth-century gasoline-powered wooden launch listed on the National Register of Historic Places. The review meeting, which rotates its hearings around the state, was held in Oswego.

"The *Forward* shipwreck nomination passed by a unanimous vote," said Mark Peckham, the state's National Register of Historic Places coordinator.

The *Forward* State Register nomination will be signed by the State Historic Preservation officer and will then go to the U.S. Department of the Interior to be listed on the National Register of Historic Places. That could take several months.

When the *Forward* is listed on the National Register, it will join several other Lake George shipwrecks with that recognition: the seven 1758 bateau wrecks called the Wiawaka Bateaux (listed in 1992), the 1758 *Land Tortoise* radeau (listed in 1995 and became a National Historic Landmark in 1998) and the 1893-built *Cadet* ex *Olive* steam launch (listed in 2002). Bateaux Below conducted the archaeological mapping on those shipwrecks and also wrote the initial nomination drafts.

Today, the *Forward* is one of the lake's Submerged Heritage Preserves, an underwater park for scuba divers with three shipwreck sites. The state park opened in 1993 with two preserves: seven colonial bateaux known as "The Sunken Fleet of 1758" and "The *Forward*." In 1994, a third shipwreck preserve site, "*Land Tortoise*: A 1758 Floating Gun Battery," was added.

Of all the shipwrecks in Lake George, the *Forward* is undoubtedly the most visited by divers. It lies in 37 to 42 feet of water, approximately 1,500 feet east of Diamond Island. Originally called "The *Forward*" preserve in 1993, the site was enhanced in 1997–1998 when a small grant was awarded to Bateaux Below from the Fund for Lake George, Inc. The remodeled preserve now has a series of informational stations about lake ecology and is called "The *Forward* Underwater Classroom."

The *Forward* came onto the lake in 1906, originally owned by William K. Bixby of Bolton Landing. The June 16, 1906 issue of the *Lake George Mirror* newspaper described it as "forty-five feet in length with a six foot beam and carries two thirty horse power engines, being a twin screw propeller." The luxury watercraft had a top speed of twenty-two miles per hour. The *Forward* was reportedly built in Morris Heights, New York, by the Gas Engine and Power Company and Charles L. Seabury & Company, Consolidated. That boatyard later became Consolidated Shipbuilding, one of the nation's most famous shipbuilders until it closed in the 1950s.

In its later life, the *Forward* was an excursion boat owned by Leonard Irish and Alden Shaw. In 1929, the vessel's crew rescued eight passengers from the *Miss Lake George* tour boat that caught fire from a motor mishap. Oral tradition hints that, in the 1930s, the *Forward* caught fire and sank, possibly abandoned.

Twentieth-Century Shipwrecks

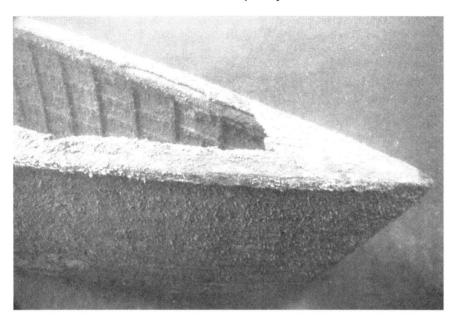

This underwater photograph shows the bow of the *Forward*, a shipwreck that was listed on the National Register of Historic Places in 2008. *Courtesy of Bob Benway/Bateaux Below.*

Reportedly, the *Forward* was found and vandalized by several souvenir-seeking divers in the 1970s and 1980s. In 1989, it was located by Bateaux Below and then archaeologically mapped. Since the shipwreck has become part of the lake's shipwreck preserves in 1993, Bateaux Below makes about fifteen team scuba dives each year to monitor the site.

Authors' note: In November 2008, the Forward *shipwreck was listed on the National Register of Historic Places.*

LAKE GEORGE'S SUNKEN VESSEL *ONAWAY II* LOCATED

Published June 25, 2010, Lake George Mirror

One of the Lake George shipwrecks on Bateaux Below's "wish list" of sunken vessels to find was located several weeks ago. Named the *Onaway II*, the thirty-two- to thirty-three-foot-long wooden runabout is designated BBI-195 in Bateaux Below's submerged cultural resources inventory.

Lake George Shipwrecks and Sunken History

In 1988, Bateaux Below began its shipwreck inventory of Lake George, a monumental effort using diver reconnaissance and side scan sonar to search, find and identify shipwrecks. The goal has been to complete a full lake shipwreck inventory to aid in managing Lake George's submerged cultural resources.

Information on the wreck of the *Onaway II* first came from Bill Henderson. He worked most of his adult life in the marina business in Cleverdale, New York, starting out as a young dock boy. Henderson stated that his dad, Scott Henderson, sank the "*Onaway II*...in about 1948."

On January 9, 1999, Bill Henderson, by then retired from the marina business, told Bateaux Below that his family's boats were named *Onaway*, taken from the name of a lodge owned by his grandmother.

Before Henderson's death, several years ago, he wrote a column in the newsletter of the Lake George Antique Boat and Auto Museum. In that publication, Henderson described the *Onaway II*. In 1923, his father built an "all-mahogany launch," similar to the first *Onaway* but "somewhat broader in the beam." Henderson wrote that the vessel was sold to a man named Sullivan, who renamed the boat *Zing*. The Freihofer family then reportedly acquired the launch and renamed it *Doughnut Queen*. Eventually, Henderson's family reacquired it, and the vessel became their workboat. Circa 1947–1948, Henderson's father and a marina employee took the aged watercraft out into the main part of the lake and "opened the hull drain, chopped holes in her," and Bill Henderson's father fired his shotgun over the sinking boat, a ceremonial salute.

When Bateaux Below divers visited the shipwreck, the team measured it at approximately thirty-two to thirty-three feet long. The *Onaway II* sits upright, its white wooden hull nearly intact, except for damaged planking on the aft deck. Two notable hull features are a pair of wooden bilge fins that served to limit roll and a reverse-raked V-shaped transom. Wooden coaming, a raised protection around the vessel's long cockpit, is still present. Its gasoline engine and steering wheel are missing. All decorative ornaments and functional metal hardware—light fixtures, horn, line cleats, rudder and more—have likewise been removed. Several rocks, used to help sink the watercraft, lie inside the hull, a sign of vessel abandonment. Most of the rocks are under the aft deck, indicating that the vessel probably sank stern first. Some ceiling planking is torn up inside the launch's large cockpit. Two small holes cut into the bow above the waterline possibly served to secure a towline to take the once majestic launch to its final resting place.

Twentieth-Century Shipwrecks

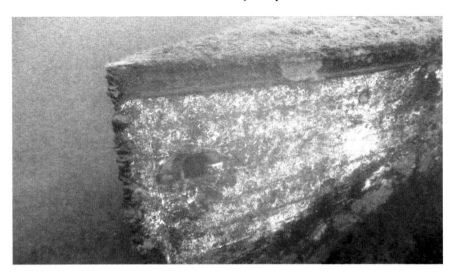

This underwater photograph shows the *Onaway II* shipwreck, a thirty-two- to thirty-three-foot-long wooden vessel that was abandoned in the lake in the 1940s. The wreck was found in 2010. *Courtesy of Bob Benway/Bateaux Below.*

Bateaux Below's 2010 shipwreck inventory fieldwork is supported by a 2009 grant of $5,000 from the Fund for Lake George, Inc.

There are no plans to make the wreck part of the lake's Submerged Heritage Preserves, a state-administered dive park for scuba enthusiasts. When Bateaux Below completes its shipwreck inventory fieldwork for the year, a report on the 2010 shipwreck finds will be sent to one of the state agencies responsible for custodial care of submerged cultural resources on state lands. According to the Abandoned Shipwreck Act of 1987 and state laws, the sunken vessel is state property.

Recent Shipwreck Find a Reminder of a "Lucky Fisherman"

Published July 16, 2010, Lake George Mirror

A recent shipwreck find in Lake George reminds us that the lucky fisherman is not always the one who catches fish. On May 26, 2010, Bateaux Below members—Bob Benway, John Farrell, Steven C. Resler and Joseph W. Zarzynski—located the burned hull of a twenty-eight-foot-long wooden

shipwreck found on the east side of the lake five miles north of Million Dollar Beach. Archival research combined with the archaeological record tells a fisherman's tale worth sharing.

On August 21, 1934, two fishermen, William Carleton and George L. Weer, were waiting for their friend, Alton J. Minton, so they could go out for a summer fishing trip. According to the August 23, 1934 *Glens Falls Post-Star*, Minton decided not to attend, a "last minute" decision. So, shortly after Carleton filled his boat's fuel tank, he and Weer departed hoping to enjoy their fishing excursion. Shortly after motoring onto the lake, an explosion rocked the stern of the watercraft. The ignition, under the rear seat of the motorboat, aft of the pilot and passenger forward cockpit, is where Minton would have sat. The loud explosion reportedly blew debris twenty-five feet into the air.

Carleton and Weer jumped into the lake and swam to shore as flames devoured most of the boat's upper works and its sides down to the bilge. The vessel burned until lake water extinguished the fire. What remained of the runabout, described as "practically worthless," was brought to shore. The *Post-Star* newspaper article stated that Minton, a cashier at a Hudson Falls, New York bank, "probably would have met instant death" from the accident.

This twenty-eight-foot-long wooden runabout caught fire after an explosion at the beginning of a fishing trip in 1934. One man, dubbed the "lucky fisherman," decided not to go on the fishing excursion. That decision saved his life, as the engine explosion occurred near the seat where he would have sat. *Courtesy of Bob Benway/Bateaux Below.*

Following the shipwreck discovery, divers from Bateaux Below visited the wreck, designated as BBI-196. The team took photographs and examined the sunken relic, a shipwreck found using an L-3 Communications–Klein Associates side scan sonar. The sonar was acquired from an Environmental Protection Fund grant administered by the New York State Department of State. Bateaux Below's 2010 shipwreck inventory fieldwork is supported by a 2009 grant for $5,000 from the Fund for Lake George, Inc.

The scuba inspection revealed the shipwreck is missing its hardware. Its engine, engine exhaust pipe, fuel tank, steering wheel, deck adornments, propeller shaft and propeller are gone. What is left is the lower hull, part of the transom and sections of the forward deck and starboard side gunwale. It is hypothesized the vessel, measured at twenty-eight feet long, was salvaged after being taken to shore after the fire. Salvaging a vessel's hardware following a mishap was a common practice during the Great Depression. Then the hulk reportedly was taken offshore and sunk.

Based on boat length, the shape of the bow, the transom design, disarticulated chrome striping found on the lake bottom and the exhaust hole location in the transom, the vessel could be a Gar Wood–built boat.

The story of this maritime mishap, however, does not end on the lake bottom. Archival research indicates that Mr. Minton's most successful fishing trip was one that he never joined. Minton, a Hudson Falls resident, lived a dozen years after the 1934 boating accident. He died in 1946 at the age of sixty-two, victim of a heart attack. At the time of his death, he was vice-president of the Fort Edward-Hudson Falls Savings and Loan Association. A good businessman for over four decades, Minton may have been a better fisherman. On his lucky day, August 21, 1934, Minton somehow instinctively knew it was a bad day for a fishing trip on a friend's boat.

Chapter 5
HISTORIC PRESERVATION & THREATS TO SHIPWRECKS

Historic Preservation Legislation Remembered

August 18, 2006, Lake George Mirror

Anniversaries are periods of reflection, a time to recall the past while looking to the future. The year 2006 marks the anniversary of two noteworthy historic preservation acts, the 100th anniversary of the Antiquities Act (1906) and the 40th anniversary of the National Historic Preservation Act (1966). These legislative benchmarks are the foundation for local, state and federal historic preservation statutes that safeguard and manage our nation's historic and cultural resources.

The Antiquities Act of 1906 is considered to be the federal legislation that began the historic preservation movement in the United States. Signed into law by President Theodore Roosevelt, a New Yorker, it prohibited the excavation of antiquities from public lands without first acquiring a permit from the U.S. secretary of the interior. It also authorized the president to proclaim national monuments of historic landmarks. As a result, over one hundred national monuments have been created, including sites like the Statue of Liberty in New York and Montana's Little Bighorn Battlefield.

In 1966, the National Historic Preservation Act (NHPA) was passed by Congress and signed by the President Lyndon B. Johnson. The NHPA recognized that, during the post–World War II era, many of our nation's

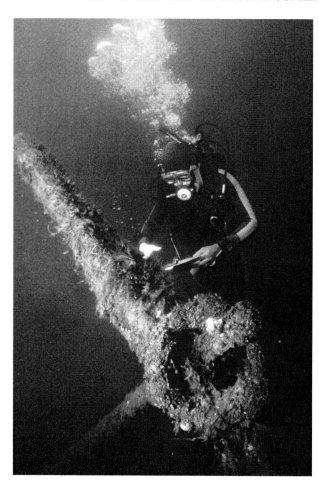

Historic shipwrecks and their artifacts, like this eighteenth-century anchor in Lake George, are protected in American waters by a collection of preservation laws. Here, Bateaux Below's Joseph W. Zarzynski records this colonial anchor. *Courtesy of Dr. Russell P. Bellico/Bateaux Below.*

most historical structures were being destroyed by development. Thus, the NHPA established the National Register of Historic Places, a roster of "districts, sites, structures, and objects significant in American history, architecture, archeology, and culture."

There are several Lake George–area properties on the National Register of Historic Places. Among them, with the year they were listed, are the Sagamore Hotel Complex (1983), Old Warren County Courthouse Complex (1973), Royal C. Peabody Estate (1984), United States Post Office–Lake George (1989), Grace Memorial Union Chapel on Sabbath Day Point Road (1982), Silver Bay Association Complex (1980) and Wiawaka Holiday House (1998).

Lake George also has several shipwrecks on the National Register of Historic Places: the seven 1758 shipwrecks known as the Wiawaka Bateaux

(listed in 1992), the 1758 *Land Tortoise* radeau (listed in 1995) and the steam-powered launch *Cadet* ex *Olive* (listed in 2002).

Furthermore, novelist Edward Eggleston's Owl's Head estate, located on Dunham's Bay, was designated a National Historic Landmark (NHL) in 1971. Lake George's fifty-two-foot-long *Land Tortoise* radeau shipwreck was listed as a NHL in 1998, only the sixth shipwreck in American waters with that recognition. The NHL designation is only for properties that are historically significant on a national level.

To commemorate the anniversaries of the Antiquities Act of 1906 and the National Historic Preservation Act (1966), Bateaux Below will install a new sign at the 1758 *Land Tortoise* radeau shipwreck. The signage, funded by the Department of Environmental Conservation, will inform divers about the radeau's National Register and NHL status.

Americans are a people of diverse ethnic, cultural and religious backgrounds. The following quote from the National Historic Preservation Act reminds us of the role of historic preservation in the lives of Americans: "The historical and cultural foundations of the Nation should be preserved as a living part of our community life and development in order to give a sense of orientation to the American people."

ZEBRA MUSSEL MONITORING STATION REACTIVATED AT SHIPWRECK PRESERVE

Published September 29, 2006, Lake George Mirror

On September 23, 2006, Bateaux Below divers installed a zebra mussel monitoring station at "The *Forward* Underwater Classroom" shipwreck preserve. The zebra mussel monitoring station is a spat trap the size of a toaster that will be maintained by Darrin Fresh Water Institute (DFWI) as part of its comprehensive program to study, control and eradicate Lake George's zebra mussels.

The zebra mussel (*Dreissena polymorpha*) is a non-native mollusk that was introduced into a North American lake in 1988, transported there from Europe in the ballast waters of a cargo ship. Since then, zebra mussels have spread into many waterways around the continent. The thumbnail-sized, black-and-white striped bivalve mollusks made their way into Lake Champlain in 1993. Shortly after that, DFWI began maintaining several spat traps around Lake George, checking for the presence of this invasive species.

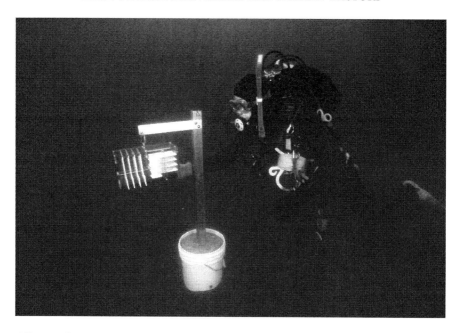

A Bateaux Below diver installs a spat trap next to the *Forward* shipwreck. The hardware monitors for the presence of zebra mussels, an invasive species that poses a threat to historic shipwrecks. *Courtesy of Bob Benway/Bateaux Below.*

In 1996, Bateaux Below members received training from New York Sea Grant in zebra mussel monitoring and, soon afterward, began a program to be a watchdog at Lake George's three Submerged Heritage Preserves, looking for the presence of veligers (juveniles) and adult zebra mussels. Bateaux Below's zebra mussel program lasted for three years and then was abandoned, largely because it was believed the lake's low calcium and pH levels were not high enough to sustain a zebra mussel colony. One fear is that zebra mussels could colonize on historic shipwrecks, and their collective weight might damage fragile wrecks.

Ironically, it was two Bateaux Below divers, Bob Benway and Joseph W. Zarzynski, who unexpectedly found zebra mussels in Lake George on December 18, 1999, during a dive to collect litter from the southwest corner of the lake. That discovery launched an effort led by DFWI to hand-harvest zebra mussels to control the spread of the exotic species. Since then, Bateaux Below divers have made approximately 275 volunteer dives with DFWI, combing the lake bottom and collecting zebra mussels. Amazingly, this effort has minimized the proliferation of the species throughout the waterway.

The zebra mussel station that was recently installed at the *Forward* shipwreck preserve was manufactured for Bateaux Below in 1996 by Bill Appling and Benway with materials donated by AngioDynamics, a Queensbury, New York medical device manufacturing firm.

The reactivation of the *Forward* preserve station, located at a depth of nearly forty feet, will be the deepest zebra mussel monitoring spat trap in the lake. Periodic removal and lab inspection of collection plates from the zebra mussel monitoring station will be conducted by DFWI. The *Forward* preserve's spat trap will serve an educational purpose, too, informing scuba divers of the importance of being proactive in the local campaign to minimize the spread of these invasive mollusks.

Spread of Zebra Mussels Could Threaten Lake's Shipwrecks

Published July 13, 2007, Lake George Mirror

July 8–14, 2007, is Adirondack Park Invasive Species Awareness Week, and environmental groups scheduled several informational activities to educate the populace about the spread of invasive species into the Lake George watershed. Exotic species like zebra mussels, Eurasian milfoil and others not only have biological and ecological effects on Lake George, but they also threaten an important cultural fabric—its historic shipwrecks.

One invasive species that could damage Lake George's noteworthy collection of shipwrecks is *Dreissena polymorpha*, more commonly called zebra mussels. These black-and-white striped, thumbnail-sized mollusks are from Russia and the Ukraine. They were first found in North America in 1988. The pesky aliens probably were introduced from a vessel from eastern Europe that entered the St. Lawrence Seaway and traveled into the Great Lakes region. There, the ship's ballast waters were released, introducing zebra mussels to the North American continent.

Zebra mussels are aggressive filter feeders that attach to hard underwater substrates like rocks, docks, water intake pipes and even shipwrecks. Underwater archaeologists are concerned because not only will zebra mussel colonization at sunken vessels obscure construction details, but their collective weight can also collapse fragile historic shipwrecks. Furthermore, several studies have shown that zebra mussels also accelerate the corrosion

of iron fasteners on shipwrecks, thus threatening the lifespan of these submerged vessels.

Initially, it was hoped that Lake George's low calcium and pH levels could not sustain zebra mussels. However, on December 18, 1999, Bateaux Below divers made the first discovery of adult zebra mussels at Lake George. Since then, Bateaux Below members have worked as volunteer divers, done non-diver fieldwork and also provided computer aided drawing (CAD) technology and boat support to the Darrin Fresh Water Institute's zebra mussel eradication program.

In 2006, Bateaux Below donated a spat trap to DFWI, an early-warning zebra mussel detection system. The spat trap was set up at "The *Forward* Underwater Classroom" shipwreck preserve.

Bateaux Below divers periodically inspect shipwrecks that, due to their location or other factors, have a greater probability of acquiring zebra mussel infestation. One such site is the submerged Delaware & Hudson Company marine track, a railroad track used from 1910 to 1950 to launch wooden runabouts. The track was laid underwater and ballasted with white marble, a metamorphic rock with calcium carbonate. Thus, it has the potential for elevated calcium levels that could sustain zebra mussels. Fortunately, no zebra mussels have yet been found at any Lake George shipwrecks or other submerged cultural sites.

So, as environmental watchdog organizations worked during Adirondack Park Invasive Species Awareness Week to inform people about the plight of invasive species into Lake George's ecosystem, Bateaux Below and others hope to prevent a disaster such as the spread of zebra mussels to the waterway's historic shipwrecks.

Chapter 6
Other Submerged Cultural Resources

Evidence of Lake George Lumber Industry Found Underwater

Published June 18, 2004, Lake George Mirror

Not all the historical treasures found underwater in Lake George are shipwrecks. In 2003 and 2004, Bateaux Below discovered evidence of the area's bygone lumber industry lying on the lake's bottomlands. On August 28, 2003, Bateaux Below located fourteen clusters of logs in Bolton waters during the last day of a two-day side scan sonar survey. The log clusters were found during a multi-year project to inventory the lake's shipwrecks, submerged marine railways and sunken piers. Bateaux Below's 2003 seventeen-day submerged cultural resources inventory fieldwork was supported by a $3,000 grant from the Fund for Lake George, Inc.

This was not the first time the group's members had encountered a cluster of logs that had sunk during transportation to a mill. On April 23, 1989, following a remote sensing survey in the waterway's southern basin using a Klein 531 side scan sonar, Bob Benway and Dave Van Aken dived to a more than one-hundred-foot depth to ground truth a sonar target. After their scuba exploration, Benway reported the target was not a shipwreck but rather was an assemblage of cut timber, each about thirteen feet long and twelve inches in diameter. Two chains, spaced about four feet apart, were

wrapped perpendicularly around the timber pieces to bind them together. The logs might be resting on a sled, probably lost through ice during a winter accident.

It was not, however, until a dive to one of the recently found log clusters sunk in the lake that archaeologists realized that transporting cut timber to sawmills in Bolton Landing, Ticonderoga and Caldwell (Lake George) was a sophisticated affair. During a November 7, 2003 dive, Benway and Joseph W. Zarzynski determined the recently found log clusters were configured differently than the one investigated in 1989. The sunken timbers they inspected consisted of over a dozen logs of nearly regular lengths resting side by side. Two logs, thinner in diameter, were placed as transverse pieces and spiked down to create a crude raft-like platform. The divers measured the log cluster at twenty-six feet in length, with its widest part a log that

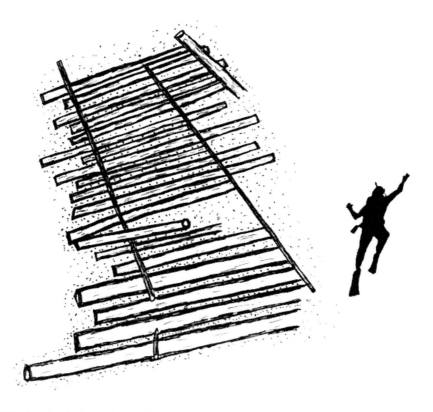

This drawing depicts a cluster of submerged logs from the lumber era that was found in the lake in 2003. The log "raft" apparently sank on its way to a sawmill. *Courtesy of Joseph W. Zarzynski/Bateaux Below.*

was sixteen feet, five inches long. The team sketched the structure and shot underwater photography and videography.

Following the reconnaissance dive, the research team uncovered a historical reference that possibly describes the purpose of these fourteen log clusters. During the nineteenth century, trees were cut from the hillsides around Lake George and then were brought down to the lakeshore. There the timber was sometimes fashioned into square- or rectangular-shaped rafts. Loggers then rigged a mast and sail onto this unique "watercraft" to propel it to its destination, like Bolton's Sawmill Bay, where it was finished into lumber.

On May 13, 2004, Vincent J. Capone and Zarzynski used a Klein 3000 side scan sonar, a new development in sonar technology, to detect another of these log clusters, the fifteenth found within the last year.

"The advanced technology of the new Klein 3000 system has allowed us to discriminate between cut logs and errant trees sunk in the lake," said Capone, owner of Black Laser Learning and a trustee of Bateaux Below.

It is not known for sure why these timber rafts were lost in the lake. They may have been part of a log drive transported by steamboats, or possibly they were one of the multiple-layered rafts bound for the mill. If they were the latter, then these log clusters are submerged cultural resources and are the component parts of one of the most unusual types of watercraft to ever travel on the Queen of American Lakes. Future archival and fieldwork investigation, including a study of all the raft-like structures and their spatial distribution, may reveal more about Bolton's mysterious sunken log clusters.

Unfortunate Milestone Reached: Thirty Thousand Pieces of Litter Removed from Lake

Published August 24, 2007, Lake George Mirror

In August 2007, scuba divers with Bateaux Below reached an unfortunate milestone, the collection of thirty thousand pieces of modern-day litter removed from Lake George. For over a decade and a half, during several hundred scuba dives, divers have collected garbage from the bottomlands of the lake, trying to keep the waterway pristine.

The group's first priority is the study of historic shipwrecks found in Lake George. However, when the opportunity has presented itself, divers have removed litter from the lake's bottomlands, off public beaches, around

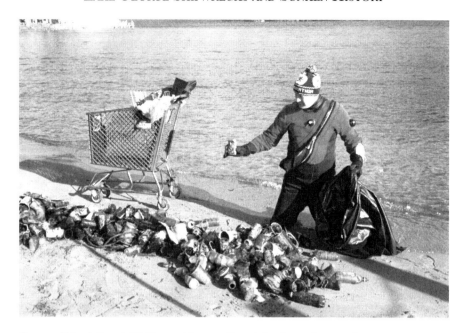

Bateaux Below's Joseph W. Zarzynski counts litter following a dive with Bob Benway off a Lake George beach. The underwater archaeology team and several colleagues make regular trash collection dives to help keep the historic waterway pristine. *Courtesy of Bob Benway/ Bateaux Below.*

public docks and even during the underwater swim from the dive boat to and from shipwreck sites.

"We're an underwater archaeology group, but simply put, we got sick and tired of seeing Lake George's bottomlands littered with garbage," said Bob Benway. "So, one day we decided to do something about it."

On August 19, 2007, the underwater archaeology team collected their 30,000[th] piece of litter—an aluminum beer can—from Lake George. The volunteer work is part of a Water Stewardship Program promoted by the New York State Department of Environmental Conservation.

Each piece of garbage is counted, inspected for the presence of zebra mussels and then placed into a trash bag. The number of pieces of litter collected and its location are then recorded.

Over the years, several divers have on occasion helped during Bateaux Below's cleanup dives, especially Steven C. Resler, New York State Department of State; Paul Cornell, New York State Divers Association; Bill Appling, AngioDynamics; and John Wimbush and other scientists with Darrin Fresh Water Institute (DFWI).

Lake George is called the Queen of American Lakes, yet few people realize that the waterway has become a refuse site for aluminum cans, bottles, plastic cups, food wrappers, golf balls and other trash discarded by people.

The cold fresh water of Lake George is an amazing preserver of historic shipwrecks and litter, too. A glass bottle has an estimated decomposition life of 1 million years; a plastic bottle, 450 years; an aluminum can, 80 to 200 years; a foam plastic cup, 50 years; and a plastic bag, 10 to 20 years.

Probably the most famous piece of litter found in the lake was a beverage bottle with two zebra mussels attached. That find was made by Benway and Joseph W. Zarzynski on December 18, 1999, during a dedicated cleanup dive in the southwest corner of lake. That marked the initial discovery of adult zebra mussels found in Lake George. Since then, Bateaux Below has volunteered as divers, shore support staff and CAD technicians for DFWI's zebra mussel eradication program.

The hope is that this litter collection effort will remind others to properly dispose of trash in garbage cans, so it will not end up in the beautiful and historic waterway referred to as the Queen of American Lakes.

Authors' note: As of the end of 2010, Bateaux Below and its friends have removed over thirty-nine thousand pieces of modern-day litter from Lake George.

Launching Wooden Runabouts Using Lake George's "Submarine Railway"

Published September 28, 2007, Lake George Mirror

In 1882, the Delaware & Hudson Canal Company, later known as the Delaware & Hudson Company (D&H), opened a railroad track from Glens Falls to Caldwell (Lake George). The D&H presence on the lake continued until 1958. That nine-mile-long transportation link opened Lake George to a steady flow of tourism, as people could then travel by train from New York City to Lake George.

Twenty-eight years later on June 17, 1910, the *Lake George Mirror* newspaper reported that the D&H had constructed a "submarine track" at the south end of Lake George "to facilitate the unloading of launches from railroad car direct into the water…permitting a boat having six feet draught to be floated clear of cars." Thus began four decades of the D&H

bringing wooden runabouts to Lake George and then safely launching them into the waterway.

Known as the "submarine railway," the marine track extended several hundred feet into the lake. The 1913 edition of S.R. Stoddard's *Lake George and Lake Champlain: A Book of To-day* listed rates for using the marine railway, ranging from ten dollars to thirty-five dollars.

In 1937, the *D&H Bulletin* published an article entitled "'Sea-Going' Railroad at Lake George." The story provided details on the working mechanics of the submerged rail system.

The D&H marine track ran into the lake at an angle of forty-five degrees to the station tracks. A 500.0-foot-long length of steel cable was threaded through a pulley block and stretched along the track leading to the railroad station. Thus, it was impossible to exert a straight pull, as the locomotive drew from the lake with a boxcar attached by the cable. When launching, a boxcar approached the lake, and its end doors opened "to reveal…[a] sleek mahogany runabout resting in its cradle." The boxcar was slowly backed into the lake to a depth of 2.0 to 3.0 feet, as "the stern of the boat" emerged "from the open end door." The boxcar was then pulled from the lake by a locomotive as the boat floated offshore. According to D&H records, the marine launch was retired on November 11, 1950, as 674.5 feet of track had been "removed" and a section of track "retired in place in Lake." The death knell of the submarine railway was due to three factors: 1) the construction of nearby Million Dollar Beach, 2) the rise of using trucks to launch and retrieve recreational boats and 3) the gradual demise of the D&H presence at Lake George.

Bateaux Below studied the submerged track from 1993 to 2000. That mapping project revealed that 205.6 feet of D&H track still lies in the lake, with 125.6 feet of that intact. The surviving marine track lies in 5.0 to 15.0 feet of water off the Beach Road between the Steel Pier and Million Dollar Beach. Numerous pieces of white marble act to ballast and support the physical hardware of the track.

In 2002, Bateaux Below erected a blue and yellow historic marker on the shoreline that overlooks the Submarine railway. The signage reads:

Other Submerged Cultural Resources

REMAINING SECTION OF THE D&H "SUBMARINE RAILWAY" IN LAKE GEORGE, NY

This drawing shows the remains of the D&H marine track at the south end of Lake George. *Courtesy of Bob Benway/Bateaux Below.*

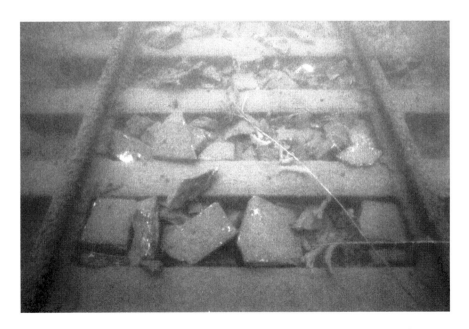

Underwater photograph of the D&H marine track. *Courtesy of Bob Benway/Bateaux Below.*

Submerged Track

Offshore lies D&H "Marine Track" in 5–15 ft of water. Operated from 1910–1950. Boats launched off railcars. 205 ft of spur survives

Bateaux Below

That same year, 2002, the Warren County Historical Society installed a historic sign entitled Delaware & Hudson Marine Railway. It lies about 150 feet southeast from the blue and yellow historic marker.

The remains of the surviving section of the submarine railway are today testimony to an era from 1910 to 1950 when rail brought wooden runabouts to Lake George.

Submerged D&H Marine Track Damaged

Published September 17, 2004, Lake George Mirror

On August 20, 2004, Bateaux Below's Bob Benway and Joseph W. Zarzynski discovered that the historic Delaware & Hudson Company (D&H) marine track, found in shallow water at the head of the lake, had been damaged. One of the site's wooden ties was dislodged, and intact rail was lifted from its seed atop wooden ties. The find was made during a monitoring dive to check the submerged track and also to inspect it for the presence of zebra mussels.

The D&H marine track was constructed in 1910. When it opened, the *Lake George Mirror* referred to it as a "New Submarine Railway" that was built "to facilitate the unloading of launches from railroad car direct into the water."

The marine track was unique because of the method by which boats were launched. A cable was attached to a boxcar, the latter holding a wooden runabout in a cradle. The boxcar ran along a submerged track until the boxcar was in deep enough water so the runabout floated off the cradle. According to a 1937 *D&H Bulletin* article, about two or three boats each week were launched using this track.

Other Submerged Cultural Resources

From 1993 to 2000, Bateaux Below surveyed the D&H's surviving section of submerged track, lying in 5.0 to 15.0 feet of water. Approximately 205.6 feet of marine track still survives, with 125.6 feet of that section having rail that was completely intact; the remaining 80.0 feet consisted only of bedding timbers with the ties and rail removed.

Following the August 20, 2004 discovery of damage to the submerged cultural resource, Bateaux Below divers returned to the site over a three-day period to record the extent of the damage and photograph it. Furthermore, the team determined that the structural damage was due to an errant boat anchor that had snagged one of the wooden ties. The anchor, attached to the wooden tie, acted as a large crowbar that loosened the metal rail and also popped out some of the railroad spikes that held the rail to the ties. It seems the damage was due to a large boat or multiple vessels rafted together that anchored over the marine track during moderate to heavy winds.

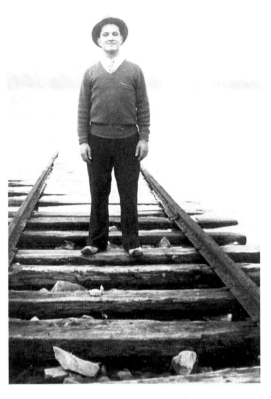

This early photograph is of the D&H marine track at Lake George when it was in use from 1910 to 1950. *Courtesy of Laura Tavormina.*

The archaeology squad plans to meet with local officials to discuss options to protect the historic underwater railway from further structural degradation. One option includes designating a "no anchor" zone around the submerged track.

Is Lake George Holy Water? Divers Find Hindu Statuettes in the Lake

Published July 3, 2009, Lake George Mirror

Two household Hindu statuettes, both measuring a little less than one foot in height and length, have been found in Lake George. The discoveries were made in 2005 and 2008 by underwater archaeologists with Bateaux Below.

The first sunken statuette was found on October 19, 2005. Some of the metal statuette deity's arms were broken. The artifact was left in the lake, and Bateaux Below contacted state authorities to report the find. The artifact was identified as being the Hindu demon-fighting goddess Durga, sitting atop a tiger.

State officials claimed no ownership of the artifact since it was less than fifty years old and, thus, not historic. They granted permission for the object to be removed. The religious figure's location was marked, and it was retrieved. Bateaux Below personnel then met with Warren County Sheriff officials to determine if the Hindu statuette had been stolen. The sheriff's office indicated they had no reports of any such theft.

Bateaux Below then contacted an Albany, New York–area Hindu temple. A temple official stated that since the statuette had been damaged, it was no longer of religious significance, and they had no interest in it.

Coincidentally, over the autumn of 2005, the Museum of London in the United Kingdom opened an exhibit on Hindu objects collected by people from the mud flats along the Thames River in Britain. Museum curators wondered if London's Hindu worshippers might have thrown these statuettes into the Thames River, a symbolic ceremony to release the objects to find their way back to the sacred Ganges River in India. Another hypothesis was that the Thames was a surrogate river for the Ganges. Finally, a more plausible theory emerged. When a Hindu statuette is broken, it is not used for religious purposes, and it is sometimes immersed in water to bring good fortune.

After finding out that the statuette had not been stolen and that the Hindu temple was not interested in receiving the religious object, Bateaux Below returned the artifact to the lake in the location where it had been found.

On November 29, 2008, Bateaux Below divers discovered a second Hindu statuette in the lake. Like the initial discovery, the ceramic figurine was found in shallow water and was likewise damaged. It was identified as being the Hindu deity Ganesh, the elephant-headed god of good fortune and wisdom.

Other Submerged Cultural Resources

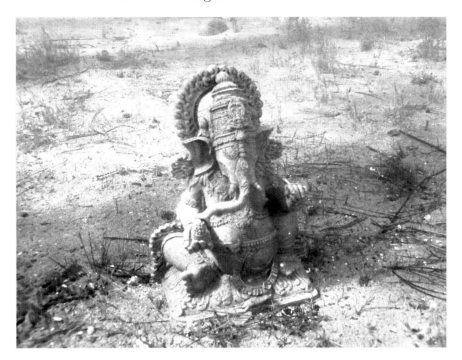

This underwater photograph is of a statuette of the Hindu deity Ganesh. Discovered in 2008, this statuette was placed into Lake George during a Hindu religious ceremony. *Courtesy of Bob Benway/Bateaux Below.*

It was photographed in place and left undisturbed. The statuette may have been deposited into the lake as part of an immersion ceremony to celebrate the birthday of the popular deity.

These finds are extremely rare but do occasionally happen. In 2008, scuba divers located a broken Ganesh statuette in Lake Travis, Texas. Furthermore, in 2007, rescue divers searched the Des Plaines River in Illinois for a Hindu woman who reportedly disappeared while conducting a ritual of submerging a Hindu statuette. Fortunately, law enforcement officials found the woman unharmed.

So, as the United States becomes increasingly multicultural, more sunken Hindu statuettes may be uncovered in waterways around the country. The two religious objects found by Bateaux Below represent a powerful statement about Lake George, that its waters have been chosen by some Hindus as a proper repository for their precious household deity statuettes. Bateaux Below members plan on writing an archaeological paper on this topic for cultural resource management purposes.

Counting "What Lies Below"

Published September 23, 2004, Lake George Mirror

Since 1988, principals of Bateaux Below have conducted side scan sonar and scuba diver reconnaissance surveys to locate, count and document the wide spectrum of maritime resources that are sunk in Lake George. This inventory is a fundamental aspect in the management of the waterway's historic shipwrecks, sunken piers and submerged marine railways. Characterized by both low- and high-tech fieldwork that is financed on a shoestring budget and fueled by plenty of volunteer sweat equity, the endeavor has nevertheless produced noteworthy results.

A key piece of equipment used in this archaeological investigation is Klein side scan sonar, high-tech gear that scans the lake bottom looking for shipwrecks. The sonar unit consists of a towfish, a towing cable and graphic recorder. The sonar towfish, shaped like a missile and about four feet long, is towed by a cable behind the survey boat, and it images the lake bottom in a swath of coverage that is generally 150 meters or more wide. For the past several years, the sonar has been integrated with global positioning system (GPS) so that shipwreck-like targets can be easily relocated and investigated.

As of the summer of 2004, approximately 50 percent of Lake George's bottomlands have been surveyed using remote sensing and scuba diver reconnaissance. As of late July 2004, a total of 195 submerged cultural resources have been located and are included in Bateaux Below's inventory. This total represents 167 sites; some sites have multiple shipwrecks. The inventory list is categorized as follows: 1 Native American bark canoe, 37 colonial bateaux, 1 replica bateau, 1 colonial radeau (named *Land Tortoise*), 1 colonial sloop, 4 colonial vessels (class undetermined), 27 rowboats, 2 modern canoes, 5 naptha- and/or gasoline-powered launches, 11 steam-powered vessels, 1 research submarine, 17 runabouts, 2 cabin cruisers, 8 sailboats, 1 motorsailor, 3 racing boats, 15 barges, 1 inflatable boat, 1 guideboat, 3 workboats, 2 trucks, 1 automobile, 9 submerged marine railways, 1 submerged colonial wharf, 2 submerged crib-style docks, 1 snowmobile, 1 safe, 2 steam boilers, 2 fuel tanks, 1 iron axle off a ways, 1 colonial anchor, 1 "sledge," 16 log clusters, 1 stove, 8 unclassified shipwrecks and 4 unidentified objects.

When shipwrecks are found, baseline information about each is recorded: location, class of vessel, length, width, centerline orientation, how the vessel

Other Submerged Cultural Resources

This underwater photograph shows one of the seven cannon ports on the 1758 *Land Tortoise* radeau shipwreck. The radeau is one of over two hundred known shipwrecks in Lake George. *Courtesy of Bob Benway/Bateaux Below.*

met its demise, lake bottom type and more. Periodically, Bateaux Below reports the results of its submerged cultural resources survey to the State of New York, the custodial caretaker of this heritage.

The inventory project is integral to both the study of underwater archaeology at the lake, as well as the management of Lake George's underwater cultural resources. With limited financial resources and time, the inventory will help archaeologists develop a list of research priorities so that they can concentrate on those submerged cultural resources of which there is little or no archival information. Furthermore, the study will help determine which shipwrecks are eligible for nomination to the National Register of Historic Places and which wrecks might be added to the waterway's Submerged Heritage Preserves.

It is estimated it will take another six to eight years or more to complete this inventory survey at Lake George. In the meantime, each year new discoveries are being made that increase our knowledge of the people and the vessels so important in the region's history.

Bateaux Below is indebted to the Fund for Lake George, Inc., the Preservation League of New York State, Klein Associates, Inc., Marine

Search & Survey, Enviroscan, Inc., and Barkentine, Inc., for their support during the inventory survey. Furthermore, Dr. Russell P. Bellico and Scott Padeni deserve thanks for their contributions that have added to the Lake George submerged cultural resources inventory list.

Authors' note: As of December 2010, Bateaux Below's submerged cultural resources inventory list totaled 201 sites with approximately 230 individual cultural resources; some sites have multiple shipwrecks. Over 65 percent of the lake has been searched.

CHAPTER 7

REPLICA ARCHAEOLOGY, ART/SCIENCE, DIVERS AND AN URBAN LEGEND

REPLICA ARCHAEOLOGY: 1758 BATEAU "WRECK" SUNK IN LAKE GEORGE

Published Fall 2008, NYSAA Newsletter, *New York State Archaeological Association, Buffalo, New York*

On June 20, 2008, Bateaux Below members and other volunteers sank a replica "shipwreck" at the Queen of American Lakes. The thirty- to thirty-one-foot-long, full-size replica 1758 bateau wreck was built over a six-month period by Maple Avenue Middle School (Saratoga Springs, New York) students, under the direction of technology class teachers Jeff Sova, Preston Sweeney and Karen Cavotta and with advisory support from Bateaux Below. The replica was placed into shallow water, about four feet deep, off the southwest corner of the lake near the Lake George Visitor Center.

The replica shows what a 250-year-old bateau-class shipwreck would look like. The vessel's upper strakes (side boards) and some frames would have fallen off. Sinking rocks were placed inside the warship's skeletal remains.

Local and state government agencies granted permission for the replica sinking. The replica wreck will be in the lake for up to three years. It helps commemorate the 250th anniversary (1758–2008) of the Sunken Fleet of 1758, when British soldiers at Lake George deliberately sank over 260 bateaux and other warships to place them in cold storage. Generally sunk in

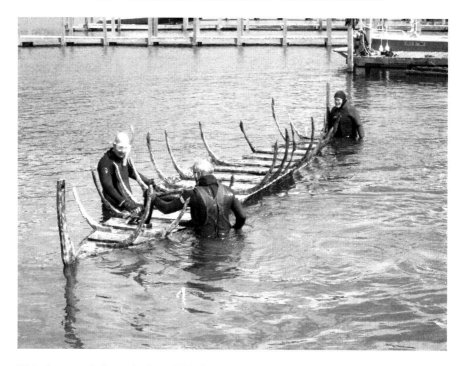

This photograph shows the June 2008 sinking of a replica 1758 bateau "wreck" at Lake George, done for pedestrian viewing. Local middle school students built the replica wreck. Pictured (from left) are Joseph W. Zarzynski, Steven C. Resler and John Farrell. *Courtesy of Bob Benway/Bateaux Below.*

fifteen to forty feet of water, this unusual eighteenth-century military strategy protected the British vessels from French raiders over the winter of 1758–1759, when British forces retired from the lake. Many of the submerged warships were retrieved by the British in 1759, possibly as many as 75 to 80 percent, and were then used in the 1759 campaign. Since 1987, Bateaux Below underwater archaeologists have been studying the Sunken Fleet of 1758, and they have located over forty sunken bateaux in the lake.

The bateau was the utilitarian watercraft of its time. Used by the Dutch, English (later known as British) and French, the flat-bottomed watercraft was pointed at bow and stern. It was generally rowed and was made of pine planks with hardwood frames, stem and sternpost. Many historians believe the French and Indian War was won not necessarily because of the might of British muskets, but rather it was due in large part to their ability to build thousands of bateaux that moved troops and supplies along the "water highways" of the thirteen colonies.

Replica Archaeology, Art/Science, Divers and an Urban Legend

Most of the bateaux sunk in Lake George in the autumn of 1758 were built in bateau "factories" in Schenectady and Albany. They were then transported by water to Fort Edward and brought by wagon over a fourteen-mile-long wilderness road to Lake George.

The replica shipwreck is best observed when the lake is calm. It lies about fifteen feet off the walkway near the visitor center. The wreck is not for scuba diving or snorkeling but rather for pedestrian viewing. The Village of Lake George erected an informational sign near the wreck. A brochure on the replica, written by Bateaux Below, has been printed by the New York State Office of General Services and is available at the visitor center.

The materials to construct the replica were paid for by Bateaux Below. The lead government entities supporting the project were the Village of Lake George, the Office of General Services and the Department of Environmental Conservation. The replica archaeology project was an after-school enrichment class that helped students learn about colonial history, underwater archaeology and museum exhibits.

The June 30, 2008 edition of the *Glens Falls Post-Star* newspaper acknowledged the project, stating: "Bravos to Bateaux Below, a group that studies shipwrecks in Lake George, for giving ordinary residents a glimpse of history by sinking a replica of a bateau in shallow water in the Southern Basin of Lake George."

Lake Art to Be Exhibited in Gallery, Internet and Underwater

Published June 12, 2009, Lake George Mirror

The summer of 2009 is the 250th anniversary of British General Jeffery Amherst's 1759 military campaign that forced the French from the north end of Lake George and the Champlain Valley. To commemorate the anniversary and promote art/science collaboration, the Lake George Arts Project will host an art exhibit that can be viewed in their gallery, on the Internet and even underwater in Lake George.

Entitled "Raising the Fleet: An Art/Science Initiative," the August 25–September 10, 2009 show will feature the work of Albany artist Elinor Mossop. The genesis for the exhibit began in 2008 when cell biologist Dr. Sam Bowser and science artist Elinor Mossop teamed with Bateaux Below.

The partners conducted an art/science project centered on Lake George's Sunken Fleet of 1758, an event when the British deliberately sank over 260 of their warships to put them into cold storage over the winter of 1758–1759. Many of the sunken bateaux were raised and used in the 1759 Amherst expedition.

In 2008, Bowser and Bateaux Below members made dives to sunken bateaux, collecting micro-size single-cell organisms called testate amoebae from the lake sediment. Archaeological renderings of the Sunken Fleet of 1758, drawn by Bateaux Below and Mossop, were scanned, assembled into quilt design-type mosaics and reduced to miniature scale. Bowser and Mossop then transformed the reduced mosaics into three-dimensional (3-D) images. Tiny testate amoebae gathered from the sediment around sunken bateaux were then released onto the 3-D surfaces. Bowser and Mossop employed a sophisticated scanning electron microscope to inspect the single cell organisms crawling about the archaeological drawings. Mossop then interpreted the creatures exploring the 3-D images and produced a series of cutting-edge illustrations. The project investigates the micro-creatures that

Bateaux Below members (from left) Joseph W. Zarzynski, Bob Benway and John Farrell prepare to sink an easel into Lake George for an underwater art/science exhibit held in 2009. *Courtesy of Pete Benway.*

inhabit the French and Indian War bateaux found in Lake George, and the art is an innovative way to inform the public about this scientific endeavor.

State officials have given permission to have the art exhibited underwater, too. Custom-built easels, designed by Bateaux Below's Bob Benway and fashioned by employees at Miller Mechanical Services in Glens Falls, will hold Mossop's artistic creations. Furthermore, reproduced on waterproof paper, Mossop's art will be installed in the lake at "The Sunken Fleet of 1758" shipwreck preserve, an underwater park for divers. Thus, scuba enthusiasts can plunge into forty feet of water to view the art displayed on easels erected around a shipwreck. The underwater exhibit will be a first for the Queen of American Lakes.

The Museum of Underwater Archaeology, an Internet-based museum that provides cyberspace viewing of special maritime projects, will likewise showcase the exhibit.

The Lake George Arts Project gallery exhibit shall feature an informational video prepared by Pepe Productions and will also include a diorama assembled by Bateaux Below ship modeler John Farrell. The diorama depicts how the underwater exhibit at the shipwreck preserve is being set up. The gallery exhibit's opening reception is August 28, 5:00 to 8:00 p.m., and it is open to the public.

Finally, the Lake George Arts Project will sponsor a three-hour, August 29, 2009 workshop at the Wiawaka Holiday House. Entitled "Beyond the Bateaux: An Art/Science Initiative Workshop," it will be taught by artist Chris Moran. The workshop examines "the nature of art/science collaboration through a visual arts experience." The workshop is free, but space is limited. Preregistration is required.

Wrapping Up the Art/Science Exhibit

Published September 18, 2009, Lake George Mirror

Feedback is still coming in, but early reports indicate that the recent Lake George exhibition—"Raising the Fleet: An Art/Science Initiative"—was a grand success. The innovative program commemorated the 250th anniversary (1759–2009) of the British salvaging part of their Sunken Fleet of 1758. Some of those warships were repaired and used by British General Jeffery Amherst's army in the 1759 military campaign that pacified the French forts

This is one of Elinor Mossop's art pieces from a 2009 art/science exhibit. She wrote, "In this drawing I shrank a 30–35 ft. long sunken bateau down to the size of an amoeba test [shell] and placed the two types of structures in one landscape." *Courtesy of Elinor Mossop.*

in the Champlain Valley and propelled the British empire to victory in the French and Indian War.

The tri-exhibit included a gallery exhibition at the Lake George Arts Project, an underwater art/science exposition for scuba enthusiasts with easels erected around a replica bateau wreck at "The Sunken Fleet of 1758" shipwreck preserve and an Internet display at the Museum of Underwater Archaeology. The program ran from August 25 to September 10, 2009.

Kurt Knoerl, director of the Museum of Underwater Archaeology (MUA), a University of Rhode Island–based website, said that, over the seventeen days of the MUA exhibit, there were 3,018 visitor "hits" on the exhibition.

Knoerl stated, "The 'Raising the Fleet' Internet exhibit had the most visitors over the shortest period since I started the Museum of Underwater Archaeology."

Furthermore, the first day of the "Raising the Fleet" cyberspace display set a Museum of Underwater Archaeology record for single-day visitation to that website. Though the art/science exhibition has formally ended, the Internet exhibit is still available for viewing at http://www.themua.org/raisingthefleet.

Following the exhibit, Bateaux Below divers and other project partners began removing the underwater exhibit. Nonetheless, the eleven two-foot by three-foot art reproductions will continue to be a source of public introspection and scientific investigation.

Cell biologist Dr. Sam Bowser, one of the exhibit's principal organizers, said that some art reproductions that were in forty feet of water are being preserved for future study. Bowser will examine one piece of art that was in the underwater exhibit, using a scanning electron microscope to inventory the tiny organisms that settled onto the artwork during the subsurface display. This acts as a surrogate to provide an inventory of the micro-fauna and micro-flora that settled onto the preserve's shipwrecks without having to conduct an invasive investigation of the cultural resources.

"Knowing which organisms colonize newly submerged surfaces is an important part of understanding preservation processes underwater," said Bowser.

Furthermore, K-12 teachers will utilize some of the underwater artwork in forthcoming art/science instruction.

"Integrating art and science is not a fad—it's a proven way to draw interest to science, especially among youngsters who think science is 'too complicated' or 'not real' to them. These kids just need to see how art and science are really 'done' the same way—with equal parts of imagination and concentration," added Bowser.

Finally, artist Elinor Mossop, Bowser, shipwreck modeler John Farrell and underwater archaeologist Joseph W. Zarzynski—partners in the "Raising the Fleet: An Art/Science Initiative" tri-exhibit—will present a poster on their program at the January 2010 Society for Historical Archaeology's Conference on Historical and Underwater Archaeology at Amelia Island, Florida.

STATE SCUBA CONVENTION IN LAKE GEORGE

Published June 5, 2009, Lake George Mirror

For nearly five decades, the New York State Divers Association (NYSDA) has held annual conventions where scuba enthusiasts have enjoyed diving, camaraderie and spent money at motels and restaurants. Each year the convention has rotated from one state waterway to another. From June 19–

21, 2009, NYSDA will hold its convention at Lake George. As local officials worry about the economic recession and its effect on tourism, it is a welcome sign that Lake George's spectacular waters and its shipwrecks will attract out-of-area sport divers.

NYSDA was organized in 1961. The not-for-profit organization is dedicated to promoting scuba diving. Bateaux Below's Terry Crandall, NYSDA president for a few years in the 1960s, recalls those early conventions at Lake George.

Crandall reflected, "For several years in a row in the sixties, the NYSDA Convention was held at the Dunham's Bay Lodge. We'd take motorboats to Diamond Island, have picnics, and dives around the island were popular."

NYSDA has also been a supporter of Lake George's Submerged Heritage Preserves, underwater parks for divers. These are designated wrecks where underwater archaeologists have created site plans, mooring buoys have been installed, underwater guidelines and signs have been erected and an informational brochure and website have been developed.

In 1993, Lake George's underwater parks for divers opened with two shipwreck preserves, "The *Forward*" and "The Sunken Fleet of 1758." The following year, "*Land Tortoise*: A 1758 Floating Gun Battery," a third preserve, was established. The *Forward* and Sunken Fleet bateaux preserves were expanded in 1997–1998. The 1906-built *Forward* gasoline-powered launch wreck became "The *Forward* Underwater Classroom," and a replica bateau was sunk at "The Sunken Fleet of 1758" preserve.

NYSDA past president Paul Cornell said, "One of the reasons the convention comes to Lake George is so members can dive the shipwreck preserves." Cornell noted that diving the underwater state park is free, a bargain during tough economic times.

The *Forward* and the Sunken Fleet of 1758 bateaux opened Memorial Day weekend, and the 1758 *Land Tortoise* radeau, a French and Indian War floating gun battery, opens the second Saturday in June. The historic shipwrecks in all three preserves have been listed on the National Register of Historic Places, and the *Land Tortoise* is also a National Historic Landmark.

"We usually have a big turnout whenever we go to Lake George," commented James Sears, NYSDA's president, about the upcoming scuba convention. "Diving doesn't get any better than this."

Replica Archaeology, Art/Science, Divers and an Urban Legend

LAKE GEORGE URBAN LEGEND REACHES WASHINGTON, D.C.

Published August 6, 2010, Lake George Mirror

It seems Lake George has an urban legend! An urban legend is modern folklore believed by its tellers to be true. An urban legend, however, does not necessarily mean the story originated in an urban setting. Rather, it denotes a modern legend compared to one that is traditional lore.

A popular urban legend and one you may have heard is "The Hook." A young couple is parked one night on an isolated lane. It's summer and the vehicle's windows are partially open. The radio is playing. The music is interrupted by a news alert. A murderer with a missing hand and metal hook has escaped from an asylum. Suddenly, the couple hears a strange scraping sound emanating from a back window of the vehicle. Startled, they drive off and later discover a bloodied metal hook attached to the car's open window.

Recently, an emerging urban legend manufactured and cultivated over the years at a popular Lake George summer camp found its way to the offices of the U.S. Navy's Naval History and Heritage Command in Washington, D.C.

In mid-May 2010, the Naval History and Heritage Command contacted Bateaux Below, a not-for-profit corporation that studies Lake George shipwrecks. The navy official, underwater archaeologist Dr. Bob Neyland, stated that a person from his office brought to his attention a story about a Lake George shipwreck. It seems that years ago while attending Adirondack Camp, a summer camp for kids at the north end of the lake, the then young camp attendee dived down to an "early British shipwreck" while swimming off forestland not far from the camp. Years later that camp alumna told her story at work.

Since one of the many tasks of the Naval History and Heritage Command is to oversee and protect foreign military shipwrecks in American waters, Dr. Neyland asked Bateaux Below for more information.

The century-old Adirondack Camp is a coed summer camp for kids, ages seven to sixteen. Each summer, the picturesque Adirondack Camp houses approximately 190 kids and has a reputation as one of the best summer camps in the Northeast.

Bateaux Below contacted the camp director, Matt Basinet, and asked about the shipwreck story. There is a small wreck, not off the camp, rather lying

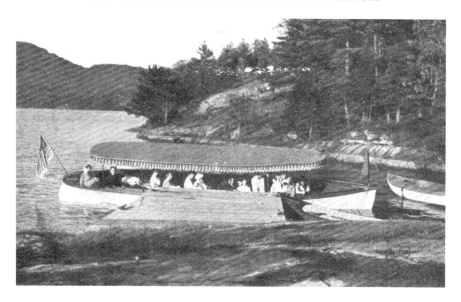

This early postcard shows a wooden launch at the Adirondack Camp. A shipwreck similar to this vessel is part of an urban legend that has attracted lots of attention. *Courtesy of Bob Benway Collection.*

adjacent to nearby land. Snorkelers from the summer camp sometimes visit the sunken boat. It appears that, over the years, possibly around a burning campfire, staff and attendees fabricated a story—an urban legend—about the mystery watercraft. The tale has changed over the years, but the current version has a female ghost, a rocky cliff and a fabled wreck.

Bateaux Below's Dr. Russell P. Bellico, a summer resident of Hague and author of the new book *Empires in the Mountains*, knows the shipwreck. Bellico says the well-known wreck is not "an early British shipwreck" but a "lightly constructed launch" with an engine, possibly a Sexton boat built in Hague and later abandoned.

Bateaux Below's Joseph W. Zarzynski visited the Adirondack Camp this summer and presented a lecture on Lake George's Sunken Fleet of 1758. There, an eager young boy told the story of the female ghost and the wreck. Camp director Matt Basinet said it is a popular tale for the kids, one with widely dispersed misinformation. Thus, Lake George's urban legend continues to grow.

Replica Archaeology, Art/Science, Divers and an Urban Legend

What to Do with Replica 1758 Bateau "Wreck" in Lake

Published September 3, 2010, Lake George Mirror

What do you do with a replica of a full-size, thirty- to thirty-one-foot-long, 1758 bateau-class "shipwreck" lying in the shallows of Lake George that soon will have to be removed? That is a question that cultural resource managers are now debating.

In June 2008, the replica wreck was sunk in four feet of water off the Blais Walkway along the southwest corner of the lake. Technology class students from Maple Avenue Middle School in Saratoga Springs, New York, built the replica during the 2007–2008 school year. Bateaux Below paid for the material and assisted the teachers.

The permit to sink the replica, issued by the New York State Office of General Services, was for three years. Thus, the shipwreck must be removed by June 2011. However, Bateaux Below members want to retrieve it in late 2010, so as not to conflict with June 2011's heavy tourist activities.

The project not only taught schoolchildren about Lake George's sunken history, it also provided an opportunity for non-divers to see what a colonial shipwreck would look like, viewed from the safety of shore.

The colonial bateau is iconic to the lake's history, as it was the utilitarian watercraft of the colonial period. Twenty-five to forty feet in length, the

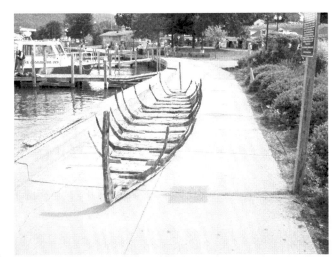

This photograph, taken in June 2008, shows a full-scale replica of a 1758 bateau "wreck." The replica was put into the lake for pedestrian viewing, and in 2010, cultural resource managers were debating what to do with it as it gets older. *Courtesy of Bob Benway/Bateaux Below.*

flat-bottomed watercraft, pointed at bow and stern, was the principal vessel on the lake during the French and Indian War (1755–1763). In the autumn of 1758, the British deliberately sank 260 bateaux to protect them over the winter from their enemy, the French. Many bateaux were successfully raised in 1759 and reused by the British. However, over 40 sunken 1758 bateaux remain in the lake and have been the focus of a twenty-three-year study by Bateaux Below.

The replica is nicknamed "B.A.T.," named after three key supporters of the project: Mayor Bob Blais, Village of Lake George; Alan Bauder, New York State Office of General Services; and Terry Crandall, Bateaux Below.

Two shoreline signs, erected by the Village of Lake George and the Office of General Services, give information about the sunken vessel. The replica is also featured in the DVD documentary *Wooden Bones: The Sunken Fleet of 1758* (http://www.woodenbones.com).

The submerged replica's structural integrity has likely deteriorated since it was sunk in the lake in June 2008. So it is still to be determined if it can have another "life," possibly recovered from the lake and used as an exhibit piece. Several options for its renaissance include donating it to a local museum or school or creating an outdoor shore-side display on underwater archaeology.

An avant-garde possibility is to offer the replica's material—its wood—to local artists, asking them to create interpretive art. Prior to the development of historic preservation in the United States in the twentieth century, wood from hulks and shipwrecks was sometimes carved into canes and chess pieces and even recycled as construction material for buildings.

In 2009, Bateaux Below assisted cell biologist Dr. Sam Bowser and artist Elinor Mossop on an innovative exhibit at the Lake George Arts Project, entitled "Raising the Fleet: An Art/Science collaboration exploring the frontiers of Lake George." So, if one uses a little imagination, it is easy to visualize an art exhibit showcasing the skeletal remains of B.A.T. reincarnated into other shapes through the dexterity of artists' hands.

The replica is the property of Bateaux Below, but suggestions for its next career are welcomed.

Authors' note: At a December 9, 2010 meeting of government officials and non-government groups, it was recommended that Bateaux Below should petition the Office of General Services to extend the permit to keep the replica 1758 bateau "wreck" in the lake, thus optimizing pedestrian viewing of it.

CHAPTER 8
SHIPWRECK DOCUMENTARIES, SHIPWRECK PRESERVES AND BATEAUX BELOW

DOCUMENTARY ABOUT LAKE GEORGE BEING FILMED

Published July 27, 2007, Lake George Mirror

Following the success of the 2005 award-winning documentary *The Lost Radeau: North America's Oldest Intact Warship*, the team that created the production about Lake George's 1758 *Land Tortoise* shipwreck is working on a new documentary film about Lake George. Pepe Productions and Bateaux Below are collaborating on a new DVD that has been in production for a year and a half. The partners are keeping a low profile on details, but the latest venture is about the underwater archaeological investigation of French and Indian War shipwrecks and other submerged cultural resources.

On July 21, 2007, the production team began obtaining new underwater video for the latest documentary. This supplements existing video archives, some a decade and a half old. The new footage, being shot during the next two to three weeks, is being acquired using a $4,100 high-definition digital underwater video system. The camera, housing and lighting unit were purchased this month, with $2,000 coming from part of a $3,000 grant from the Fund for Lake George, Inc., and $2,100 from Bateaux Below. Part of the latter funds came from royalties from Pepe Productions' sales of the DVD documentary *The Lost Radeau* (http://www.thelostradeau.com). The new digital video system replaces an aged eight-millimeter underwater video camera.

"The camera will also be used during our shipwreck inventory fieldwork, to document the lake's three state shipwreck preserves and for other underwater historic preservation and environmental projects at Lake George," said John Farrell of Bateaux Below.

Documentary filmmaking has become important to Bateaux Below. The archaeological process of investigating a shipwreck starts with defining the research problem and then progresses to background research, acquiring permits, assembling a team, data acquisition and processing, analysis, interpretation and publication. Far too often, funding runs out, or archaeologists are off on other projects before completing the final stages of a site study. Without a museum to exhibit the results of research, Bateaux Below has had to devise innovative methods to exhibit its work. Creating documentaries is an effective interpretation of archaeological investigation for a savvy television- and DVD-watching public.

As this second documentary filmmaking project nears completion, there is a special upcoming event for *The Lost Radeau*. There will be an area showing of the fifty-seven-minute-long documentary on August 26, 2007, at 7:00 p.m. at the three-hundred-seat Charles R. Wood Theatre in Glens Falls. Pepe Productions, Bateaux Below, Black Laser Learning and Whitesel Graphics have donated *The Lost Radeau* for a one-evening theatrical presentation. Tickets cost five dollars, with all proceeds going to support the Wood Theatre, a not-for-profit corporation. Several members of the filmmaking team will be present to discuss *The Lost Radeau*.

THE LOST RADEAU TO APPEAR ON PBS TELEVISION

Published June 20, 2008, Lake George Mirror

October 22, 2008, marks the 250th anniversary of the sinking of Lake George's 1758 *Land Tortoise* radeau, a British floating gun battery from the French and Indian War that in 1998 was designated a National Historic Landmark by the U.S. Department of the Interior. To commemorate the anniversary, Peter Pepe, director of the documentary *The Lost Radeau: North America's Oldest Intact Warship*, is allowing PBS television stations in New York state to run the production at no cost to PBS. According to Pepe, a Glens Falls resident, "Nine PBS affiliates in New York state have been granted permission to broadcast the program."

Shipwreck Documentaries, Shipwreck Preserves and Bateaux Below

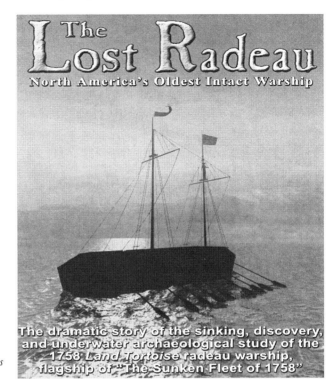

Poster of the DVD documentary *The Lost Radeau: North America's Oldest Intact Warship*. Courtesy of Pepe Productions & John Whitesel.

The DVD production was released in November 2005 and has won three national awards for "excellence in video production." It tells the colonial history of the 1758 radeau, its deliberate sinking by the British to hide it from French raiders, the 1990 discovery of the *Land Tortoise* by Bateaux Below and the archaeological study and management of the one-of-a-kind sunken warship.

John Whitesel of Queensbury and Joseph W. Zarzynski, a Wilton resident, wrote the script. The documentary was in production for over one and a half years and was the collaborative effort of Pepe Productions, Bateaux Below, Whitesel Graphics and Black Laser Learning.

In February 2008, Zarzynski contacted Peter Repas, executive director of the Association of Public Broadcasting Stations of New York. Zarzynski recalled Repas's earlier career as an aide to state senator Ronald B. Stafford and knew that he was familiar with the *Land Tortoise*. Zarzynski asked Repas to introduce the documentary to PBS stations around the state to determine their interest in airing it around the 250th anniversary of the sinking of the radeau. Repas succeeded in getting his program managers excited about the documentary.

According to Pepe, the PBS affiliate in Syracuse, New York, wants to start running the production this autumn to coincide with the radeau's 250th anniversary and to go up against network television's new season of shows. Pepe Productions and Bateaux Below donated the documentary to New York's PBS television stations to run "a total of four times over the next three-year period." Thus, the documentary has the potential of being shown a total of thirty-six times on nine PBS stations around the state. Pepe and Zarzynski have been invited by the Plattsburgh PBS station to be "interviewed or appear in conjunction with the program."

Getting the production on PBS television is also recognition of the filmmaking talents of Peter and Joe Pepe and the skill of animator John Whitesel. Pepe Productions and Bateaux Below retain all rights to the production, and PBS has agreed to run a trailer that directs viewers to a website (http://www.thelostradeau.com) that promotes the sale of the DVD.

Some of the revenue from the DVD sales has supported underwater archaeology at Lake George. In 2007, these royalties, combined with some grant money from the Fund for Lake George, Inc., allowed Bateaux Below to purchase a $4,100 underwater digital video camera system for its projects. This year, royalties paid for printing five thousand copies of a radeau-shaped bookmark that were distributed to local libraries and schools.

Pepe said: "Most importantly, viewers of PBS throughout New York state will be made aware not only of this incredible treasure [the 1758 *Land Tortoise* radeau], but of the significance of our region's history and the role it played in the formation of this country."

According to Pepe, WMHT of Troy, New York, plans to show *The Lost Radeau* as early as mid-August 2008.

Lake George Documentary Wins Film Festival Award

Published July 23, 2010, Lake George Mirror

On July 12, 2010, the Savannah, Georgia–based Gray's Reef Ocean Film Festival announced that a recently released Lake George documentary is not only one of its official film festival selections, but that the local documentary is also one of two joint winners of the film festival's prestigious Maritime Heritage Category award. The local documentary, *Wooden Bones: The Sunken*

Shipwreck Documentaries, Shipwreck Preserves and Bateaux Below

DVD documentary cover of *Wooden Bones: The Sunken Fleet of 1758*. Courtesy of Pepe Productions.

Fleet of 1758, was released less than three months ago. The fifty-eight-minute-long DVD documentary (http://www.woodenbones.com) is a Pepe Productions and Bateaux Below documentary.

The film festival, the seventh annual, is September 17–19, 2010. The venue for the popular event is a historic theater recently renovated by the Savannah College of Art and Design. Over ninety films were submitted for consideration, and thirty-three were selected. A seven-member panel of experts picked the official selections and also chose the award winners. Only a handful of awards will be given out. Included in this year's film selections are two highly touted National Geographic documentaries.

Wooden Bones is three stories in one focused on Lake George during the French and Indian War (1755–1763). The documentary, four years in production, examines Lake George's Sunken Fleet of 1758. In the autumn of 1758, in a desperate move, the British deliberately sank over 260 warships

to protect them over the winter from French raiders. Thus, the documentary explores the history and underwater archaeological investigation of the lake's sunken bateaux, a sunken 1960 yellow sub built to photograph bateau-class wrecks and a submerged 1758-constructed military wharf.

"The documentary will inform a Georgia audience about Lake George's bountiful history and the scientific work of Bateaux Below studying the lake's underwater heritage," said Glens Falls documentary filmmaker Peter Pepe.

Wooden Bones was directed by Pepe and written by Joseph W. Zarzynski. John Whitesel fashioned the DVD's animation. Kip Grant, a Glens Falls–area radio personality, did the narration. John Farrell created the production's ship models. Among those interviewed in the documentary were historian Dr. Russell P. Bellico; National Register of Historic Places State Coordinator Mark Peckham; underwater videographer Bob Benway; Lake George Mayor Bob Blais; cell biologist Dr. Sam Bowser; coastal resources specialist Steven C. Resler; area teachers Jeff Sova, Preston Sweeney and Ted Caldwell; former archaeological diver Terry Crandall; underwater archaeologist Joseph W. Zarzynski; and Dave Decker, executive director of the Lake George Watershed Coalition.

The Gray's Reef film festival is one of two film festivals that *Wooden Bones* entered. The documentary team is waiting to hear on the other submission, a southwestern United States film festival.

"When trying to get into film festivals, which costs money to enter for consideration, independent films like *Wooden Bones* face stiff competition from well-financed big studio productions," commented Peter Pepe. "Thus, getting into any major film festival, especially one out of the region, is a significant achievement."

Maria's Reef: Bateaux Below's New Submerged Geological Preserve?

Published June 24, 2005, Lake George Mirror

Over the winter of 2004–2005, Bateaux Below members completed a site map for a proposed underwater geological park in Lake George. Darrin Fresh Water Institute's Jeremy Farrell, a geologist, also helped, providing insight into the locale's topography. Dubbed "Maria's Reef," the limestone outcropping was mapped by Bateaux Below, using high-tech remote sensing and divers.

Shipwreck Documentaries, Shipwreck Preserves and Bateaux Below

The reef is located adjacent to state land on the east side of the lake, across from Bolton Landing. It is midway between Point Comfort and Phelps Island. The oval-shaped, plateau-like limestone reef is approximately six hundred feet long by sixty to seventy-five feet wide at its top. Water depths range from twenty feet on top of the reef to over seventy feet at its base. Visibility at the site is very good, generally twenty to thirty-five feet.

In February 2003, Bateaux Below submitted a formal application to the New York State Office of General Services to create a submerged geological preserve for scuba divers. If approved, it would be the fourth in the lake's dive preserves.

A possible source to help with hardware costs for a new dive preserve is the Underwater Blueway Trail (UBT). The UBT is a New York State Department of State initiative to create underwater parks for divers in six waterways around the Empire State and link them into a trail system. This would not only provide recreation for scuba divers, it would likewise promote heritage tourism for non-divers since shoreside signage, museum exhibits and Internet-based information would be a key component.

"Maria's Reef" would certainly be unique. It would be the first underwater park in the state specifically set up for divers to explore a submerged geological site. If the limestone outcropping becomes a preserve, it would have minimal underwater signage to retain the natural beauty of the reef.

The site was mapped in 2001 by Vincent J. Capone using an Odom Hydrotrac sonar and a RoxAnn Groundmaster, the latter capable of identifying the type of lake bottom found around the reef. This high-tech equipment acoustically mapped the reef in about an hour. It would have taken divers many months to replicate that and, undoubtedly, without the same degree of accuracy. Scuba teams were later used to finalize the mapping.

"I want to see this park open," said Alan Bauder, submerged lands and natural resources manager with the New York State Office of General Services. "It is a great concept and is named after a person that was a dedicated civil servant and also a volunteer for many shipwreck projects around the state."

"Maria's Reef" is named after Maria Macri, who died several years ago after a battle with cancer. She was a volunteer firefighter, municipal historian for the Town of New Baltimore, New York, and was vice-president of the New York State Divers Association. In 1994, Macri was a volunteer diver with Bateaux Below when the "*Land Tortoise*: A 1758 Floating Gun Battery" preserve was set up.

Maria's Reef
Submerged Geological Preserve

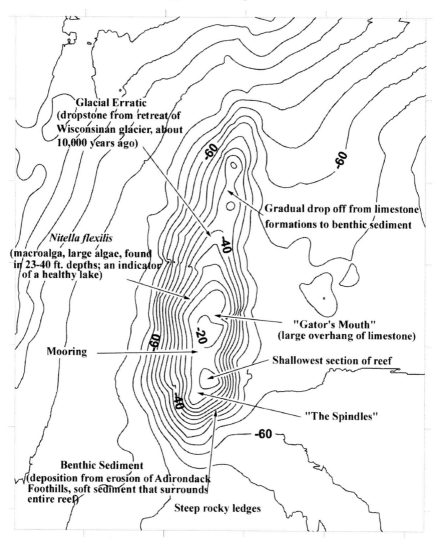

This site plan is for "Maria's Reef," a proposed geological preserve for diver visitation at Lake George. *Courtesy of Vincent J. Capone and Bob Benway/Bateaux Below.*

If created, the submerged geological park will promote stewardship of Lake George's underwater natural wonders.

Authors' note: Due to funding issues for the purchase of hardware for "Maria's Reef" and some concerns that Maria's Reef dive preserve might come into conflict with fishermen, the proposed scuba preserve has been put on hold.

Lake George Shipwreck Preserves to Get Overhaul

Published June 9, 2006, Lake George Mirror

The year 2006 marks the 100th anniversary of the Antiquities Act of 1906, the country's first cultural resource management statute. The federal law prohibited excavation of antiquities from public lands without a permit from the U.S. secretary of the interior. Thus, in the spirit of this centennial celebration of historic preservation and cultural resource management, the Department of Environmental Conservation has provided $2,000 to its Bolton Landing facility to upgrade the hardware and underwater signage at Lake George's state park for divers. The shipwreck park, known as Submerged Heritage Preserves, opened in 1993.

Each of the three historic shipwreck sites in the Lake George preserves system is marked by a pair of buoys, a white and blue round mooring buoy and a white and orange, barrel-shaped navigational aid buoy. Divers tie up their boat to a mooring buoy and then descend into the deep to "dive into history." Underwater signage and trail lines guide divers around. This unique park provides "controlled public access" to specific shipwrecks and encourages divers to become stewards of the waterway's sunken heritage.

However, like all parks from time to time, aging hardware needs to be replaced. This year, Bateaux Below, which assists the state by setting up and monitoring the preserves, will spend many days diving to replace aging underwater signage and trail lines. This is the park's first major hardware modernization since 1998.

On June 3, 2006, Bateaux Below divers began the process of installing a new trail line at "The *Forward* Underwater Classroom" preserve. The *Forward* preserve lies in 20 to 45 feet of water about 1,500 feet east of Diamond Island. The centerpiece of the preserve is a 1906-built, 45-foot-

LAKE GEORGE'S SUBMERGED HERITAGE PRESERVES
GENERIC MOORING PLAN
NOT TO SCALE

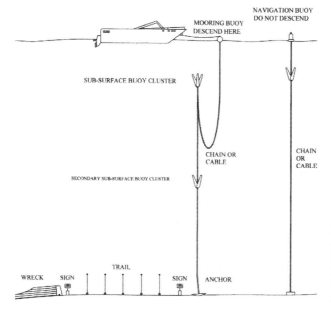

Drawing of a new generic mooring plan for Lake George's Submerged Heritage Preserves. *Courtesy of Bob Benway/Bateaux Below.*

long, wooden gasoline-powered launch named *Forward*. The Bixby family of Bolton Landing originally owned the vessel. In the 1930s, the watercraft, then under different ownership, sank during unrecorded circumstances. Over 1997–1998, "The *Forward*" preserve was remodeled, its transformation sponsored by the Fund for Lake George, Inc. Informational stations were added around the underwater site to tell divers about site vegetation, geology, fish life, water temperature patterns, color loss at depth and more.

The replacement trail being installed this year has been redesigned so that it will minimize damage from errant boat anchors and fishing tackle, something that has plagued this site the past several years. The preserve will not be closed during renovation.

Over the summer, Bateaux Below will also erect replacement signage and new signposts along the bottomlands of the other two preserves, "The Sunken Fleet of 1758" and a deepwater site known as "*Land Tortoise*: A 1758 Floating Gun Battery."

Lake George's underwater park is polishing up for its summertime visitors, just like the many terrestrial parks around the region.

REMODELING OF LAKE'S SHIPWRECK PRESERVES CONTINUES

Published August 4, 2006, Lake George Mirror

Earlier in 2006, the Department of Environmental Conservation provided $2,000 to purchase replacement hardware for Lake George's three shipwreck sites in the Submerged Heritage Preserves. Work to install the new hardware began on June 3, 2006, and will continue into the autumn. The improvement is the underwater park's second major renovation, the last coming in 1997–1998. Bateaux Below, a volunteer organization, is conducting the overhaul.

The Department of Environmental Conservation–administered park has three sites: "The *Forward* Underwater Classroom," "The Sunken Fleet of 1758" and "*Land Tortoise*: A 1758 Floating Gun Battery."

"The *Forward*" and "The Sunken Fleet of 1758" preserves opened in 1993 and are open from Memorial Day weekend into the autumn. Diving is on a first come, first served basis. The *Land Tortoise* radeau preserve opened the following year. It is open from the second Saturday of June through Labor Day. Due to the 107-foot depth of the *Land Tortoise* and because the 52-foot-long radeau is a one-of-a-kind watercraft, divers must register with the Department of Environmental Conservation at its Million Dollar Beach office before diving.

The 2006 makeover is being done over several phases. Seven new signs affixed to aluminum angle have already been installed at "The Sunken Fleet of 1758" preserve, an assemblage of seven 1758 bateau wrecks and a single replica bateau. Students from Bolton Landing, Minerva and Newcomb schools built the replica under the direction of Ted Caldwell, a Bolton Landing educator. After several years as a floating vessel, the replica bateau was deliberately sunk in 1997 to enhance diver visitation and to provide an opportunity to study wooden boat deterioration in fresh water.

In 2006, "The *Forward* Underwater Classroom" had a new 430-foot trail system installed that connects several informational stations to the site's two shipwrecks; the second shipwreck is a 20-foot-long Penn Yan class vessel that was deliberately sunk in 1997 to enhance the preserve. The 2006-installed trail system minimizes the potential of damage to the trail configuration from errant anchors and fishing tackle.

On July 29, 2006, divers started installing the first of thirteen replacement signs at the *Forward* site. Divers also began the task of removing old site hardware, using lift bags and a boat crane.

These are three of several replacement signs installed at "The *Forward* Underwater Classroom" shipwreck preserve in 2006 to upgrade the dive park. *Courtesy of Bob Benway/ Bateaux Below.*

Signage will also be added at the *Land Tortoise* preserve to inform recreational divers about this French and Indian War vessel's 1998 designation as a National Historic Landmark. In 1995, the radeau was listed on the National Register of Historic Places. The underwater marker that informed divers of the British warship's National Register listing was damaged in 2004 when a large boat or multiple boats tied up to the site's mooring during windy weather in the off-season. The four-hundred-pound mooring anchor dragged, damaging the corridor line and signage leading to the shipwreck. The park remodeling is part of an effort to make divers and non-divers more cognizant of Lake George's shipwreck preserves and to promote recreational and heritage tourism.

On June 29, 2006, the new Lake George Visitor Center opened. One of its exhibits is about the Submerged Heritage Preserves. Entitled "New York State Underwater Blueway Trail," the 2-D display was designed by Bateaux Below, Pepe Productions and Whitesel Graphics, with layout by Shannon-Rose Design and Adirondack Studios. This display is complemented by a

2.5-minute-long video, an excerpt from *The Lost Radeau* documentary about the 1758 *Land Tortoise*. The multi-dimensional exhibit was prepared for the New York State Department of State with funds provided under Title 11 of the Environmental Protection Fund Act.

Unseen Battleground: Improving the "Ring-Around-a-Radeau"

Published July 6, 2007, Lake George Mirror

About 249 years ago this autumn, in 1758, the British deliberately sank over 260 warships in Lake George to place them in cold storage over the winter to safeguard the squadron from the French. They intended to recover the wooden vessels the following year. Most of the submerged warships were thirty- to thirty-five-foot-long bateaux, the utilitarian boats of the colonial era.

The "battleship" of the Sunken Fleet of 1758 historical event was the 52-foot-long, seven-sided *Land Tortoise* radeau. Today, it is part of a state park for scuba divers called Submerged Heritage Preserves. The radeau shipwreck preserve is in 107 feet of water and is called "*Land Tortoise*: A 1758 Floating Gun Battery." PVC posts support a plastic chain that encircles the French and Indian War icon. The hardware configuration is commonly known as "Ring-Around-a-Radeau." In June 2007, members of Bateaux Below, a not-for-profit corporation that studies Lake George shipwrecks, began an endeavor to improve diver access to the underwater park and also to determine what is causing scouring at the wreck.

Bateaux Below divers, with help from Steven C. Resler, made their first 2007 visit to the radeau site on June 10. The team cleaned algae from the PVC and plastic perimeter chain that is a guide to keep divers from touching and damaging the one-of-a-kind battle craft. They also scrubbed the preserve's five underwater signs that provide information to visiting scuba enthusiasts.

Department of Environmental Conservation personnel installed a new stainless steel cable and anchor block for the preserve's navigational aid buoy on June 12, 2007. They also put in a new mooring buoy.

On June 23, 2007, underwater archaeologists erected a PVC post along the corridor that leads divers from the mooring anchor to the shipwreck known as North America's oldest intact warship. The new PVC stanchion is

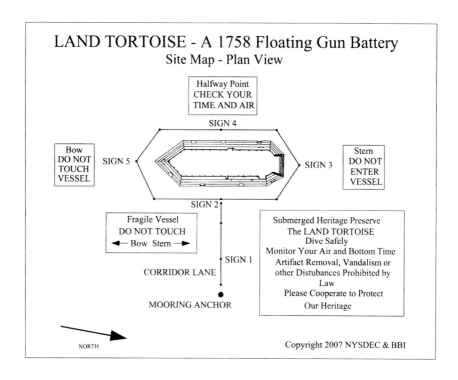

Site plan for *"Land Tortoise*: A 1758 Floating Gun Battery" shipwreck preserve. *Courtesy of Bob Benway/Bateaux Below and New York State Department of Environmental Conservation.*

a replacement for hardware that was damaged in the spring of 2004, when a large boat or multiple boats illegally tied up to the off-season buoy flotation during high winds. That resulted in the four-hundred-pound mushroom anchor being dragged, damaging the corridor lane erected in 1994, the year the radeau preserve first opened.

Furthermore, research divers will try to figure out what is causing possible scouring at the radeau. The scouring, a ditch on the lake bottom along part of the radeau, could be due to deepwater currents that could destabilize the radeau's structural integrity. This has exposed part of the hull structure. Another theory is the "scouring" may be due to the frequent passes of divers swimming around the radeau.

This year the team will map the scour signature and also visually document it, using underwater photography and videography. Bateaux Below is likewise preparing a strategy to record the presence and direction of the possible low-velocity deepwater lake current that may be present at the radeau.

If it is indeed a lake current causing the scouring, mitigation recommendations will be made to state cultural resource managers. This could include erecting a barrier alongside the wreck to deflect the hydrodynamic forces creating the scouring.

The "*Land Tortoise*: A 1758 Floating Gun Battery" will not be closed to diving during this fieldwork. It is hoped that the 2007 historic preservation efforts at the "Ring-Around-a-Radeau" will both improve public access to the site and help protect the shipwreck for next year's 250th anniversary of the sinking of the *Land Tortoise*, which is October 22, 2008.

Damaged Shipwreck Preserve Repaired and Reopened

Published July 20, 2007, Lake George Mirror

Nearly a year ago, on July 31, 2006, a Bateaux Below diver discovered that "The Sunken Fleet of 1758" shipwreck preserve's entire trail line system had been ripped away after being snagged by heavy tackle from downrigger-equipped fishing gear. Over five hundred feet of trail line that guided divers around the site and several underwater informational signs were torn up and never recovered. The shipwreck preserve for visiting sport divers was then closed.

The submerged site, in twenty to forty feet of water, consists of seven bateau-class vessels, thirty- to thirty-five-foot-long, part of 260 bateaux deliberately sunk by the British in the autumn of 1758 to protect them over the winter from French marauders. Known today as the Wiawaka bateaux because the seven shipwrecks lie off the Wiawaka Holiday House, the French and Indian War shipwrecks were mapped by Bateaux Below from 1987 to 1991. In 1992, the seven wrecks were listed on the National Register of Historic Places, the first shipwrecks in Lake George with that designation. In 1993, the seven Wiawaka bateaux became part of an underwater park for divers called Submerged Heritage Preserves. The seven sunken bateaux then became known as "The Sunken Fleet of 1758" dive site. In 1997, a three-fourths-scale replica bateau, constructed by educator Ted Caldwell's public school students, was sunk at the site to allow divers to view an intact bateau.

Following the 2006 damage, Bateaux Below members made several inspection dives late into the scuba season to determine what caused the mishap and how best to remodel the trail system to minimize future

problems. In 2007, the Department of Environmental Conservation came up with replacement line and signposts, and One Day Signs in Waterford, New York, donated the replacement signs. On May 24, 2007, scuba teams began reconstructing the trail system and replacing missing underwater signage. On July 8, 2007, the research team completed rebuilding the site's trail configuration. On July 9, 2007, the state installed the seasonal buoys at the underwater site, thus reopening "The Sunken Fleet of 1758" shipwreck preserve.

The remodeling and rebuilding of the physical hardware at "The Sunken Fleet of 1758" preserve was part of a two-year initiative to upgrade all three of the Submerged Heritage Preserves. Last year, Bateaux Below members with help from other volunteer divers made forty-eight team dives on the upgrade project as well as regular monitoring duties at the preserves.

The Wiawaka bateaux site is special to Bateaux Below. September 13, 2007, marks the twentieth anniversary of the group founding. The team's initial underwater archaeological fieldwork was recording the seven shipwrecks.

The Wiawaka bateaux and the nearby land site, the Wiawaka Holiday House, are unique, too. The Wiawaka Holiday House was founded in 1903 as a summer retreat for Troy, New York female workers. The terrestrial site was listed on the National Register of Historic Places in 1998, six years after the Wiawaka bateaux. This dual National Register listing is somewhat unique. Now that the shipwreck preserve has reopened, visitors to the Wiawaka Holiday House will again be able to view boats tied up to the shipwreck preserve's mooring buoy as scuba devotees "Dive Into History."

PAINTING LAKE GEORGE'S HISTORY

Published July 11, 2008, Lake George Mirror

Over eighty years ago, before moving to New Mexico to become one of our country's greatest artisans, modernist Georgia O'Keeffe used an artist's brush and many bold colors to create exquisite paintings of the Queen of American Lakes. Over the summer of 2008, Bateaux Below members will begin using a workman's paintbrush and two colors—blue and yellow—to repaint aging historic markers located around Lake George. This general maintenance helps commemorate the 250th anniversary (1758–2008) of

Shipwreck Documentaries, Shipwreck Preserves and Bateaux Below

the Sunken Fleet of 1758, when British troops deliberately sank over 260 warships at Lake George to prevent their capture from French raiders.

Since the early 1990s, Bateaux Below, a not-for-profit corporation that studies the lake's shipwrecks, has researched, written the text and helped fund several blue and yellow historic markers that dot the lake's shoreline. Every ten to fifteen years, however, even history needs a facelift, and these signposts need a new paint job.

The State of New York began erecting historic markers in 1925, part of an initiative to celebrate the sesquicentennial (150th anniversary) of the American Revolution (1775–1783). Back then, the two-foot-tall by three-foot-wide cast-iron markers only cost $2. Catskill Castings and its predecessor, the Walton Foundry, have been making these markers for eight decades. The foundry is located in Bloomville, New York, near Delhi. Each sign, painted "National Blue" and "Sunset Yellow," costs $795. The aluminum markers weigh fifty pounds each. A seven-foot-tall pole to mount the marker can be purchased for an additional $80.

Writing the text for these markers is a bit tricky since there are character limits. The title line has fifteen characters. The general body has five lines, each line with twenty-seven characters. A credit line of up to thirty characters and a logo map of the state are generally found on the markers, too.

The State Education Department is the caretaker of these signs if they are on state property. The state museum staff maintains a computerized inventory of the markers. They do not, however, repaint the signs, but they

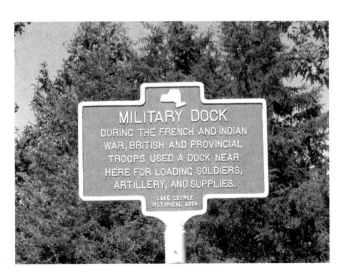

Blue and yellow MILITARY DOCK historical marker. *Courtesy of Bob Benway/Bateaux Below.*

do encourage local historical societies and civic groups to conduct periodic repainting of the roadside signage.

Since 1992, Bateaux Below, sometimes with other sponsors, has erected several blue and yellow historic markers around the lake—Military Dock, Sunken Fleet, Radeau Warship, Wiawaka Bateaux, Marine Track, Cadet Shipwreck and the Moorings. The group worked with the Lake George Historical Association to install the Military Dock and Sunken Fleet historic markers. Bateaux Below wrote the text for the Moorings sign, paid for by Bob Bailey and the Admiral Moore descendants.

This summer, Bateaux Below volunteers will begin repainting several of these historic marker signs. In future years, other blue and yellow historical markers will be repainted. For just a few dollars in paint and brushes, Lake George's rich history can be shared with the many visitors to the picturesque Adirondack Mountains waterway.

Mystery Bottle with Written Messages Found in Lake

Published September 10, 2010, Lake George Mirror

Beachcombers walking coastal shores occasionally come upon the proverbial "message in a bottle," an inanimate aquanaut that traveled many miles on its oceanic journey before landing on a far-off beach. Seldom, however, does one discover such an oddity that was deliberately sunk in a lake. So the recent discovery of such a bottle hiding in the depths of Lake George is unique, and its story is worth sharing.

The underwater find was made on August 28, 2010, at "The Sunken Fleet of 1758" shipwreck preserve, located off the Wiawaka Holiday House on the lake's east side. The estate is a renowned retreat for women founded in 1903 by Katrina and Spencer Trask and Mary Fuller.

On August 28, Bateaux Below divers were conducting an inspection of the underwater site off Wiawaka Holiday House. The divers searched the lake bottom east of the preserve's seven 1758 British bateaux, searching for Asian clams. Asian clams, an invasive species first catalogued in the United States in 1938, were recently discovered in the lake by scientist Jeremy Farrell of the Darrin Fresh Water Institute (DFWI) while on a family outing on the waterway's west side. The invasive species is detrimental to the ecology of

Shipwreck Documentaries, Shipwreck Preserves and Bateaux Below

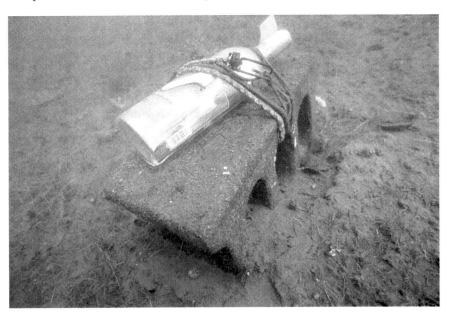

This underwater photograph is of "messages in a bottle," found in 2010 near one of the shipwrecks of "The Sunken Fleet of 1758" shipwreck preserve off the Wiawaka Holiday House. *Courtesy of Bob Benway/Bateaux Below.*

the lake. DFWI is coordinating several lake groups tasked with mapping the extent of the Asian clam invasion.

Fortunately, no Asian clams were observed at the shipwreck preserve. However, Bateaux Below divers—Bob Benway, Dr. Sam Bowser and Joseph W. Zarzynski—did detect an out-of-place object: a modern-day bottle tied to a cinder block lying in eighteen feet of water, less than ten feet from one of the sunken bateaux. Benway, who first saw the clear glass container, recognized many small notes or "messages in a bottle."

The unusual find was reported to local and state authorities and also to the Wiawaka Holiday House management. Since the bottle was modern, under fifty years old, it can be removed from the lake without securing a state permit. So, on August 31, 2010, Bateaux Below divers returned to the preserve. The modern artifact was relocated, photographed, its location mapped and the mysterious jug was recovered. After several days of drying, it was opened. Inside were thirty-four handwritten notes.

So, who wrote these messages? It appears a family that had stayed at the Wiawaka Holiday House in September 2009 apparently drafted the notes. It was mostly family members and their friends, each authoring a

short note, wishing for something that would happen before the group returned to Wiawaka in September 2010 for a reunion. Some wished for family members to get admission into certain colleges, another scribbling hoped that a family member would complete a second triathlon, another message hoped that the beautiful Wakonda lodge at Wiawaka would soon be restored and one note even asked that proof of life on another planet would soon be discovered.

These wonderfully penned messages tell a story of a caring family and their friends, each wishing good fortune upon others. Hopefully, some of their desires have been granted this past year. If so, such is the magic of Wiawaka and Lake George!

The collection of writings from the submerged bottle will be returned to the Wiawaka staff with another note, a letter from Bateaux Below offering best wishes to the group that crafted the "messages in the bottle."

Bateaux Below Celebrates Twenty Years of Underwater Archaeology

Published September 28, 2007, Lake George Mirror

On September 22, 2007, members of Bateaux Below, a not-for-profit corporation that studies Lake George shipwrecks, met in Hague to celebrate their twentieth anniversary. The group was formed on September 13, 1987, following a three-day underwater archaeology workshop held at the lake.

The group has six members: Dr. Russell P. Bellico, Hague; Bob Benway, Queensbury; Vincent J. Capone, Landenberg, Pennsylvania; Terry Crandall, Richfield Springs; John Farrell, Athol; and Joseph W. Zarzynski, Wilton. At the festivity, each member was presented with a Certificate of Recognition from the New York State Department of State. Their awards recognized the achievements of the group over the past two decades to gain a clearer understanding of the maritime history of Lake George.

From 1987 to 1991, the team mapped seven 1758 British shipwrecks known as the Wiawaka bateaux. That resulted in the sunken warships being listed on the National Register of Historic Places in 1992.

In 1990, the group used a Klein side scan sonar and discovered the fifty-two-foot-long *Land Tortoise* radeau, a British floating gun battery of the French and Indian War. Under the direction of Rhode Island archaeologist

Shipwreck Documentaries, Shipwreck Preserves and Bateaux Below

This photograph is of five of the six trustees of Bateaux Below at a 2007 meeting that celebrated the group's twentieth anniversary: (from left) Bob Benway, Dr. Russell P. Bellico, Joseph W. Zarzynski, Terry Crandall and John Farrell. *Courtesy of Barbara Crandall.*

Dr. D.K. Abbass, the group completed a survey of the deepwater shipwreck from 1991 to 1993. In 1995, the radeau was listed on the National Register, and in 1998, it became only the sixth shipwreck in American waters designated a National Historic Landmark.

In 1993, Bateaux Below joined with state and local agencies and opened the Empire State's first shipwreck park for divers, called Lake George's Submerged Heritage Preserves.

During the 1990s, the team worked in the Florida Keys helping the National Center for Shipwreck Research study several eighteenth- and nineteenth-century shipwrecks. One of those wrecks is believed to be the 1820–1822 U.S. Schooner *Alligator*. The *Alligator* sailed off Africa in antislave trading duties and also helped the American Colonization Society acquire the West African land of Liberia. Liberia was set up so that former African American slaves could return to their ancestral homeland. The *Alligator* later cruised near Florida in anti-pirate patrols. Following a raid in

Cuban waters that captured several pirate ships, the warship grounded off the Florida Keys and was destroyed to prevent capture.

Bateaux Below members have also worked with the Rhode Island Marine Archaeology Project on several projects. Among them are the archaeological mapping of the reputed slave ship *Gem* and several Revolutionary War shipwrecks that lie in Rhode Island waters, along with the search for the British transport *Lord Sandwich*, sunk off Newport, Rhode Island, during the American Revolution (1775–1783). Several years before the war, this British collier, then called the HMB *Endeavour* and led by Captain James Cook, explored Australian and New Zealand waters. The search off Rhode Island for the *Lord Sandwich* ex HMB *Endeavour* is one of the great shipwreck mysteries in maritime history.

In 1997, Bateaux Below discovered the forty-eight-foot-long *Cadet*, a Lake George steam launch wreck in Bolton waters. The team then mapped the 1893-built vessel that originally was named *Olive*. In 2002, the *Cadet* ex *Olive* was listed on the National Register of Historic Places.

The archaeology team has likewise found dozens of shipwrecks in Lake George. Among them, the 1960-built, fifteen-foot-long *Baby Whale* submarine discovered in 1995, and in 2002, they located the wreck of the thirty-five-foot-long *Miss Lake George* excursion boat.

Members of the group have likewise presented hundreds of lectures around the country and written numerous articles, academic papers and encyclopedia entries. Dr. Russell P. Bellico has also had several books published on the maritime and military history of Lake Champlain and Lake George.

So, the September 22, 2007 gathering was a salute to twenty years of underwater archaeological successes.

"Our strength is our diversity," said Terry Crandall, a pioneer archaeological diver who, in the 1960s, worked for the Adirondack Museum on a colonial shipwreck project at Lake George. "In our organization there is a historian, a sonar specialist, an engineer, an underwater archaeologist and educators. We see things from different perspectives and collectively this is our greatest asset."

Shipwreck Documentaries, Shipwreck Preserves and Bateaux Below

1987 LAKE CHAMPLAIN SHIPWRECK FIND HELPED TRAIN LAKE GEORGE UNDERWATER ARCHAEOLOGY TEAM

Published July 2, 2010, Lake George Mirror

A shipwreck discovery made twenty-three years ago on Lake Champlain, which provided early remote sensing training for two members of the Lake George underwater archaeology team known as Bateaux Below, has recently resurfaced in the national news. A June 24, 2010 Associated Press article entitled "Feds Assess Threat from Sunken Lake Champlain Tug" details a mid-June 2010 robotic investigation of a possible fuel-laden Lake Champlain shipwreck that may pose an environmental threat to that waterway.

The sunken vessel, the tugboat *William H. McAllister*, was located on August 7, 1987, by a research team using remote sensing equipment to search for the legendary "Lake Champlain monster." Instead of finding a carcass of one of the Nessie-like monsters that purportedly hide in the 120-mile-long Lake Champlain, the crew located another beast, a sunken tugboat possibly filled with thousands of gallons of diesel fuel. The 1987 shipwreck find was soon nearly forgotten, but the 2010 oil disaster in the Gulf of Mexico has reawakened interest in this Lake Champlain wreck.

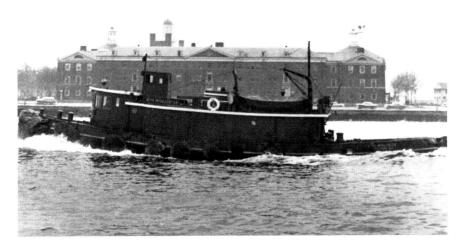

This photograph shows the tugboat *William H. McAllister*. A 1987 side scan sonar survey at Lake Champlain located the tugboat wreck. The remote sensing project was early training in shipwreck hunting for two future members of Bateaux Below. *Courtesy of Steamship Historical Society Collection, University of Baltimore Library.*

The 2010 Gulf of Mexico oil disaster became the catalyst for Lake Champlain environmentalists and maritime experts to work with the Environmental Protection Agency (EPA) to assess the structural integrity of the sunken tugboat to determine if it still holds diesel fuel. In 2010, the Vermont-based Lake Champlain Maritime Museum (LCMM) was contracted by the EPA to conduct a survey of the tugboat wreckage lying in the middle of the lake. The LCMM reportedly will receive $75,000 for the assessment study. Thus, the LCMM-led team used a tethered underwater robot, called a remotely operated vehicle, to visually inspect the wreck. The *William H. McAllister* shipwreck may hold up to fourteen thousand gallons of diesel fuel, a monster of a problem should the tugboat ever break apart. Some believe it holds little, if no, fuel.

The World War II–built tugboat, *William H. McAllister*, originally constructed in Texas for the U.S. Army and later converted for commercial use, hit a reef off Port Kent, New York, on November 17, 1963, and sank. The crew survived. Afterward, a handful of experienced scuba divers visited the shipwreck lying in over 150 feet of water. However, without the use of global positioning system (GPS) in the 1960s to relocate the site, its location was not precisely known until 1987.

Joseph W. Zarzynski led the project that found the site on August 7, 1987. The group located the sunken watercraft using a side scan sonar donated by Klein Associates, a New Hampshire firm. Klein Associates' Garry Kozak was the sonar operator, with Vincent J. Capone assisting.

The *William H. McAllister* find in 1987 was, in reality, a training session for Capone and Zarzynski. A month later, Dr. Russell P. Bellico and Zarzynski founded the organization that became Bateaux Below, a not-for-profit corporation devoted to studying Lake George's shipwrecks.

"The 1987 Lake Champlain expedition provided us with practical experience in shipwreck searching; techniques we've used many times here at Lake George," said Zarzynski, executive director of Bateaux Below. "The same kind of equipment and field methodology used in 1987 to find the Lake Champlain tugboat was employed on June 26, 1990, when we discovered the 1758 *Land Tortoise* radeau shipwreck in Lake George, today called North America's oldest intact warship."

It is not yet known if the LCMM and EPA assessment of the *William H. McAllister* will result in removing any fuel that might be found inside the sunken tugboat.

CONCLUSION

As this book heads off to The History Press for the final stages of the book publication process, a "Dive into History" initiative for divers and non-divers is gathering momentum at Lake George and at several other New York waterways. This chapter, a fitting conclusion to the book, was published in the *Lake George Mirror* just days before this book went to the publisher. This initiative, called the Underwater Blueway Trail, could usher in new interest in the sunken history of Lake George and the other major waterways of the Empire State.

Lake George Has Crucial Role in State's Underwater Blueway Trail

Published December 2010, Lake George Mirror

In mid-November 2010, the Village of Lake George Board voted to hire a coordinator to help manage the emerging Underwater Blueway Trail (UBT), a New York State Department of State program that will create or expand dive parks in six waterways around the state. The UBT has been years in development, and recent economic woes have unfortunately slowed the project's maturation.

Conclusion

Nevertheless, a big hurdle was recently overcome when the village hired a Seneca Lake–area scuba businessman to assist state and local officials in the development and promotion of the recreational and heritage tourism project. Reportedly, the Village of Lake George will receive and manage grant funds that total $220,000 in Environmental Protection Fund monies from the Department of State. The village will manage these funds for all six municipalities in the pilot project: Dunkirk (Lake Erie), Freeport (Atlantic Ocean waters), Geneva (Seneca Lake), Village of Lake George (Lake George), Oswego (Lake Ontario) and Plattsburgh (Lake Champlain). Another $100,000 is available for marketing the program through Internet websites and other innovative strategies.

A key proponent of the funding is that it must be matched dollar for dollar, most likely through in-kind services. Not-for-profit groups like Bateaux Below, principally a volunteer organization, will be critical to providing the in-kind services that will match grant funds. If this initiative is successful, the UBT has potential to attract greater recreational and heritage tourism to Lake George and the other participating municipalities and their waterways.

In September 2010, a Bateaux Below member attended a Tampa, Florida workshop on diving and heritage tourism in the Sunshine State. State officials there declared that Florida, whose tourism is mostly due to its sunny weather and beaches, nevertheless garners $5 billion annually into its economy through tourism to historic sites, history-related museums, shipwrecks, etc.

Florida's shipwreck preserve program opened in 1987 and currently has eleven shipwreck preserves. Dubbed Underwater Archaeological Preserves, these shipwrecks attract thousands of recreational divers and their families. Their spending generates millions of dollars each year into the Florida economy. Can the UBT create a similar draw for New York tourism?

In 1993, Lake George's Submerged Heritage Preserves opened. The underwater park was the first of its kind in the state. It has no park rangers and no formal budget. The Department of Environmental Conservation puts out and retrieves the seasonal mooring and navigational aid buoys, while Bateaux Below volunteers make dives to set up, monitor and break down the scuba park. There is no cost to visiting divers.

For years Bateaux Below has been trying to expand the Submerged Heritage Preserves but has met resistance. One proposed site is a limestone outcropping, a picturesque underwater geological reef on the east side of the lake across from Bolton Landing. That site, in twenty to seventy feet of water and dubbed "Maria's Reef," was named after a volunteer firewoman

Conclusion

who died of cancer. The proposed dive preserve was nixed due to lack of funding and because some thought its location near popular fishing grounds could conflict with sport fishing.

Thus, Bateaux Below and state officials are trying to come up with one to two other dive site candidates for Lake George's scuba preserves, shipwrecks that are large enough to support intensive diving. Unfortunately, most Lake George wrecks are not rugged canalboats or sturdy trade ships found in other state waters.

The key to creating a trail of shipwreck parks around the Empire State will be another important component of the UBT, promoting the state's maritime heritage through websites, shore signage, museum and visitor center displays, documentaries and other creative strategies. This will likewise draw non-divers to explore the state's historic waterways, and in so doing, it shall generate heritage tourism dollars, as well as foster historic preservation.

INDEX

A

Abandoned Shipwreck Act of 1987 87
Abbass, Dr. D.K. 39, 143
Adirondack Camp 119, 120
Adirondack Chapter—Antique & Classic Boat Society 68
Adirondack Museum 19, 20, 21, 22, 23, 38, 144
Adirondack Park Invasive Species Awareness Week 95, 96
Adirondack Trust Company 76
Alligator 143
American Colonization Society 143
American Revolution 25, 139, 144
Amherst, General Jeffery 35, 36, 38, 113, 115
AngioDynamics, Inc. 76, 95, 100
Ankle Deep 78
Ankle Deep Too 79

Antiquities Act of 1906 91, 93, 131
Antonio Lopez 40
Appling, Bill 68, 95, 100
Arizona 40
Asian clams 140, 141

B

Baby Whale (Lake George submarine) 74, 75, 108, 128, 144
Bailey, Bob 140
Barkentine, Inc. 61, 110
Basinet, Matt 119, 120
bateaux 19, 20, 21, 22, 23, 24, 35, 36, 37, 38, 75, 108, 111, 114, 115, 118, 122, 128, 133, 135, 137, 140
Bateaux Below 16, 21, 22, 23, 24, 26, 27, 28, 29, 30, 31, 32, 34, 37, 38, 39, 40, 41, 42, 43, 44, 46, 47, 48, 50, 52, 53, 56, 57,

INDEX

59, 60, 61, 62, 63, 64, 65, 66, 67, 71, 72, 73, 74, 75, 76, 77, 78, 79, 80, 81, 82, 83, 84, 85, 87, 88, 89, 92, 93, 94, 95, 96, 97, 98, 99, 100, 101, 102, 103, 104, 105, 106, 107, 108, 109, 110, 111, 112, 113, 114, 115, 117, 118, 119, 120, 121, 122, 123, 124, 125, 126, 127, 128, 129, 130, 131, 132, 133, 134, 135, 136, 137, 138, 139, 140, 141, 142, 143, 144, 145, 146, 148, 149
Battle of Valcour 25
Bauder, Alan 64, 122, 129
Bellico, Dr. Russell P. 34, 36, 38, 39, 41, 46, 50, 56, 58, 76, 77, 92, 110, 120, 128, 142, 143, 144, 146
Bellico, Jane 76
Benway, Bob 16, 24, 27, 31, 39, 40, 44, 49, 50, 51, 52, 53, 56, 57, 58, 59, 61, 62, 63, 65, 66, 68, 71, 73, 74, 76, 77, 81, 85, 87, 88, 94, 95, 97, 98, 100, 101, 103, 104, 107, 109, 112, 114, 115, 120, 121, 130, 132, 134, 136, 139, 141, 142, 143, 160
Benway, Pete 114
Birthplace of the "Modern" American Navy 25, 27
Bixby family 82
Bixby, Harold 83
Bixby, William K. 56, 83, 84
Black Laser Learning 99, 124, 125
Blais, Mayor Bob 122, 128
Blais Walkway 121

Bowser, Dr. Sam 113, 114, 117, 122, 128, 141
Buck cottage 69, 72
Burleigh, Gordon 77
Burton, Arthur 55, 70, 72
Burton, Captain W.W. 50
Burton, Harmel 55

C

Cadet ex *Olive* 43, 44, 45, 46, 93, 144
Cadet shipwreck signage 45, 140
Caldwell, Ted 82, 128, 137
Capone, Vincent J. 39, 43, 56, 61, 63, 65, 71, 78, 99, 129, 142, 146
Carleton, William 88
Catskill Castings 139
Cavotta, Karen 111
Civil War 26
colonial military wharf 128
Cornell, Paul 100, 118
Couchman, Lee 20
Crandall, Barbara 143
Crandall Library 46
Crandall, Terry 19, 20, 21, 23, 24, 26, 38, 118, 122, 128, 142, 144
CSS *Virginia* 26
Cyric 49

D

Darrin Fresh Water Institute 24, 39, 59, 93, 94, 95, 96, 100, 101, 128, 140
Davis, Norman 69

Index

Dawe, Debbie 160
Decker, Dave 128
Delaware & Hudson Company marine track 96, 101, 102, 103, 104, 105
Dennis, Charlie 20
Doughnut Queen 86
Durga 106
Durham boats 36

E

Earl of Halifax 22
Eden, John J. 69, 70, 71, 72
Ellide 48, 49, 50
Enviroscan, Inc. 110

F

Farrell, Jeremy 128, 140
Farrell, John 39, 56, 78, 87, 112, 115, 117, 124, 128, 142
Fay & Bowen runabout 76
Fort Carillon (Ticonderoga) 37
Fort St. Frédéric (Crown Point) 37
Fort William Henry 22, 37
Fort William Henry Museum 17
Forward 55, 82, 83, 84, 85, 94, 118, 132
French and Indian War 19, 22, 25, 26, 28, 30, 35, 36, 38, 39, 46, 74, 112, 115, 118, 122, 123, 124, 127, 134, 135, 137
Fuller, Mary 140
Fund for Lake George, Inc. 53, 56, 61, 63, 65, 78, 83, 84, 87, 89, 97, 109, 123, 126, 132

G

Ganesh 106, 107
Gas Engine and Power Company and Charles L. Seabury & Company, Consolidated 84
Gates, William Preston 64
Gem (Lake George) 78, 79
Gem (Rhode Island) 144
Goodness, Paul 59
Grace Memorial Union Chapel 92
Grant, Kip 128
Gray's Reef Ocean Film Festival 126, 128
Greene, L.D. 69, 70, 71, 72

H

Hamilton, Captain Frank 59, 70
Henderson, Bill 86
Henderson, Scott 86
Hindu statuettes 106, 107
Historical Society of the Town of Bolton 46
HMB *Endeavour* 144
Hummer 79

I

Inverarity, Dr. Robert Bruce 19, 21
Irish, Leonard 55, 84

J

Jones, Art 74

INDEX

K

Klein Associates, Inc. 109, 146
Klein side scan sonar 28, 34, 39, 43, 47, 56, 57, 61, 63, 65, 67, 71, 76, 78, 89, 97, 99, 108, 142, 146
Knoerl, Kurt 116
Kozak, Garry 146

L

Lake Champlain 25, 26, 30, 33, 60, 93, 144, 145, 146
Lake Champlain Maritime Museum 60, 146
Lake Champlain monster 145
Lake George Antique Boat and Auto Museum 86
Lake George Arts Project 113, 115, 116, 122
Lake George Camping Equipment Company marina 61
Lake George Historical Association 15, 16, 40, 140
Lake George litter 31, 99, 101
Lake George Mirror 23, 46, 47, 50, 52, 71, 83, 84, 101, 104, 147
Lake George Park Commission 77
Lake George Visitor Center 111, 134
Lake George Watershed Coalition 128
Lamb Brothers marina 65
Land Tortoise 26, 27, 28, 29, 30, 32, 33, 34, 39, 40, 41, 45, 47, 84, 93, 108, 109, 118, 123, 124, 125, 126, 133, 135, 142, 146

Land Tortoise: A 1758 Floating Gun Battery shipwreck preserve 33, 84, 118, 129, 132, 133, 135, 136
Lord Sandwich 144

M

Macri, Maria 129
Maine 49
Mankowski, Count Casimir S. 78, 79
Maple Avenue Middle School 111, 121
Maple Leaf 40
Maria's Reef 128, 129, 130, 131, 148
Marine Search & Survey 110
Marine Track signage 140
McMahan, Kendrick 39
Meaney, Pat 35
messages in a bottle 140, 141, 142
Military Dock signage 139, 140
Miller Mechanical Services 115
Minne-Ha-Ha (I) 51, 52, 53
Minton, Alton J. 88, 89
Miss Lake George 55, 56, 57, 84, 144
Monitor 40
Moore, Admiral 140
Moorings signage 140
Moran, Chris 115
Mosher, Charles D. 49
Mossop, Elinor 113, 114, 115, 116, 117, 122
Mountain Lake PBS television station 34
Museum of Underwater Archaeology 115, 116

INDEX

N

National Center for Shipwreck Research 143
National Historic Landmark 28, 30, 32, 34, 40, 41, 84, 93, 118, 124, 143
National Historic Preservation Act 91, 93
National Register of Historic Places 23, 25, 28, 40, 44, 57, 75, 82, 83, 84, 85, 92, 93, 109, 118, 128, 134, 137, 138, 142, 143, 144
Native American bark canoe 17, 108
New York Sea Grant 94
New York State Department of Environmental Conservation 30, 31, 33, 39, 40, 93, 100, 113, 131, 133, 135, 138, 148
New York State Department of State 31, 34, 89, 129, 135, 142, 147, 148
New York State Department of Transportation 32, 33, 34, 41
New York State Divers Association 19, 52, 100, 117, 118, 129
New York State Education Department 139
New York State Historic Preservation Office 82
New York State Museum 23, 28, 29, 30
New York State Office of General Services 64, 65, 67, 113, 121, 122, 129
New York State Office of Parks, Recreation and Historic Preservation 40, 44
New York State Police 24
Neyland, Dr. Bob 119

O

O'Keeffe, Georgia 138
Old Time Barge 46, 47, 48
Old Warren County Courthouse 92
Onaway II 85, 86, 87
One Day Signs 138
Operation Bateaux 20, 21, 38
outboard racing boat wreck 61, 62
Owl's Head estate 93

P

Padeni, Scott 71, 110
Pamelaine 63, 64, 65, 66, 67, 68
Parker, Gene 20
Parrott, James 74
PBS 34, 41, 124, 125, 126
Peckham, Mark 22, 45, 84
Peers, Addison 70
Pepe, Joe 126
Pepe, Peter 66, 124, 126, 128, 159
Pepe Productions 34, 40, 45, 66, 71, 123, 124, 125, 126, 127, 134
photomosaic of the radeau 39
Porter, N.E. 43
Potter, Captain Raphael 43
Preservation League of New York State 71, 109

INDEX

R

Radeau Warship signage 40, 140
Raising the Fleet: An Art/Science Initiative Exhibit 113, 115, 116, 117, 122
Rasputin 51, 53
Repas, Peter 125
replica 1758 bateau wreck 111, 112, 113, 121, 122
reputed 1758 radeau artifact 28, 30
Resler, Steven C. 31, 87, 100, 112, 128, 135
Rhode Island Marine Archaeology Project 144
Rodgers, Dr. Bradley 28, 65
Root, Gerald 74
Royal C. Peabody Estate 92
runabouts 47, 76, 78, 85, 96, 102, 104

S

Sagamore Hotel 43, 49, 92
Sagamore Resort 46
Saunders, Dr. George Mason 64, 65, 66, 67, 68
Scat 79
Schenectady bateau-building "factories" 36, 113
Schenectady boat 36
Schenectady County Community College 34, 35
Scioto 58, 59, 60, 70
scouring at radeau shipwreck 30, 32, 136
Sears, James 52, 118
Sea Shadow 25, 26, 27

Sexton boat 120
Shaw, Alden 55, 84
Silver Bay Association 92
Simpson, John Boulton 43
Smith, Captain Fred R. 44
Smith, Oliver and Margaret 77, 78
Society for Historical Archaeology 117
Sova, Jeff 111, 128
Staats, Leon 55
State Register of Historic Places 83
submerged cultural resources inventory 43, 46, 48, 53, 56, 61, 63, 65, 67, 71, 75, 76, 78, 80, 85, 89, 108, 110, 124
Submerged Heritage Preserves 25, 28, 39, 83, 84, 87, 94, 109, 118, 131, 132, 133, 134, 135, 137, 138, 143, 148
Sullivan, Jack 17, 20
Sunken Fleet of 1758 19, 21, 22, 24, 35, 36, 37, 75, 111, 114, 115, 120, 127, 135, 139
Sunken Fleet signage 37, 40, 140
sunken log clusters 47, 97, 98, 99, 108
Sweeney, Preston 111, 128

T

Tavormina, Laura 105
The *Forward* shipwreck preserve 83, 84, 118, 132, 133
The *Forward* Underwater Classroom shipwreck preserve 83, 84, 93, 95, 96, 131, 133, 134

Index

The Lost Radeau: North America's Oldest Intact Warship 25, 30, 34, 41, 53, 123, 124
The Sea Sled 55
The Sunken Fleet of 1758 shipwreck preserve 83, 84, 115, 116, 118, 132, 133, 137, 138, 140, 141
Thunderer 26
Town of Bolton 46
Trask, Katrina and Spencer 140
Trieste 75

U

Underwater Archaeological Preserves (Florida) 148
Underwater Blueway Trail 129, 134, 147, 148, 149
United States Post Office–Lake George 92
urban legend 119, 120
U.S. Navy 25, 26, 27, 49, 119
Utah 40

V

Vanadis 44
Van Aken, Dave 39, 97
Vandrei, Charles 31
Village of Lake George 113, 122, 147, 148

W

War of 1812 26, 33
Warren County Historical Society 104
Warren, E. Burgess 49, 50
Weer, George L. 88
Western Inland Lock Navigation Company 36
Whitesel Graphics 124, 125, 134
Whitesel, John 33, 41, 125, 126, 128
Wiawaka Bateaux 23, 24, 45, 84, 92, 137, 138, 142
Wiawaka Bateaux signage 140
Wiawaka Holiday House 23, 92, 137, 138, 140, 141, 142
William H. McAllister 145, 146
Wimbush, John 100
Wooden Bones: The Sunken Fleet of 1758 122, 127, 128
wreck formation processes 80, 81

Z

Zarzynski, Joseph W. 17, 23, 24, 27, 28, 29, 31, 35, 37, 39, 44, 48, 50, 51, 52, 56, 61, 63, 64, 65, 66, 71, 73, 74, 76, 78, 87, 92, 94, 98, 99, 100, 101, 104, 112, 114, 117, 120, 125, 126, 128, 141, 142, 143, 146, 159
zebra mussel monitoring station 93, 95
zebra mussels 93, 94, 95, 96, 101, 104
Zing 86

ABOUT THE AUTHORS

Underwater archaeologist Joseph W. Zarzynski has a bachelor of arts degree in history from Ithaca College (1973), a master of arts in teaching degree in social sciences from Binghamton University (1975) and a master of arts degree in archaeology and heritage from the University of Leicester, United Kingdom (2001). He is co-founder and executive director of Bateaux Below, Inc., a not-for-profit corporation that studies historic shipwrecks in Lake George, New York. Mr. Zarzynski has had nearly two hundred articles and professional papers published in newspapers, magazines and professional journals. He is the author of two books on underwater mysteries and also co-author of a young adult book on Lake George's 1758 *Land Tortoise* radeau shipwreck. He is also an award-winning documentary film writer and is one of the executive producers for three documentary productions: *The Lost Radeau: North America's Oldest Intact Warship* (2005, Pepe Productions), *Wooden Bones: The Sunken Fleet of 1758*

Co-author Joseph W. Zarzynski holds a model of the seven-sided 1758 *Land Tortoise* radeau. *Courtesy of Peter Pepe.*

(2010, Pepe Productions and Bateaux Below, Inc.) and *Search for the* Jefferson Davis*: Trader, Slaver, Raider* (2011, Pepe Productions). A native of Endicott, New York, Mr. Zarzynski resides with his wife, Pat Meaney, in the Saratoga Springs, New York area.

Co-author Bob Benway standing next to Lake George. *Courtesy of Debbie Dawe.*

Bob Benway is a native of Glens Falls, New York, and he resides in nearby Queensbury, eight miles from Lake George. Mr. Benway is a trustee of Bateaux Below, Inc., and also is vice-president of the Lake George Historical Association. Mr. Benway has been scuba diving in Lake George for four decades and is an accomplished underwater photographer and videographer. His underwater photographs have appeared in many publications, and Mr. Benway's underwater video has also been featured in two shipwreck documentaries.

The co-authors were part of the team that discovered the 1758 *Land Tortoise* radeau shipwreck in Lake George on June 26, 1990. The *Land Tortoise* radeau warship has been called North America's oldest intact warship.